2001

2001

.diane arbus.

An Aperture Monograph

Hardcover ISBN: 0-912334-40-1
Paperback ISBN: 0-89381-694-9
Library of Congress Catalog Card Number: 72-93191
Twenty-fifth anniversary edition, 1997

25 24 23 22 21 20 19 18 17

Aperture Foundation publishes a periodical, books, and portfolios of fine photography to communicate with serious photographers and
creative people everywhere. A complete catalog is available upon request. Address: 20 East 23rd Street, New York, New York 10010.
Phone: (212) 598-4205. Fax: (212) 598-4015. Toll-free: (800) 929-2323. Visit Aperture's website: http://www.aperture.org

Aperture Foundation books are distributed internationally through:
CANADA: General Publishing, 30 Lesmill Road, Don Mills, Ontario, M3B 2T6. Fax: (416) 445-5991.
UNITED KINGDOM, SCANDINAVIA, AND EUROPE: Robert Hale, Ltd., Clerkenwell House, 45-47
Clerkenwell Green, London EC1R OHT. Fax: 44-171-490-4958.
NETHERLANDS: Nilsson & Lamm, BV, Pampuslaan 212-214, P.O. Box 195, 1382 JS Weesp.
Fax: 31-294-415054.

For international magazine subscription orders for the periodical *Aperture*, contact
Aperture International Subscription Service, P.O. Box 14, Harold Hill, Romford, RM3 8EQ,
United Kingdom. One year: $50.00. Price subject to change.

To subscribe to the periodical *Aperture* in the U.S.A. write Aperture, P.O. Box 3000, Denville,
New Jersey 07834. Tel: (800) 783-4903. One year: $40.00. Two years: $66.00.

This book was originally made with the help of ... John Szarkowski, Lisette Model,
Richard Avedon, Neil Selkirk, Sudie Trazoff, and Sidney Rapoport.
For the twenty-fifth anniversary edition ... photographic prints by Neil Selkirk,
prints courtesy of The Robert Miller Gallery, duotone separations by Robert Hennessey,
printed and bound by L.E.G.O./Eurografica, Vicenza, Italy.

The text on the following pages was compiled from tape recordings of a series of
classes Diane Arbus gave in 1971 as well as from interviews—with Studs Terkel and with
Ann Ray Martin of *Newsweek*—and from some of her own writings.

Nothing is ever the same as they said it was. It's what I've never seen before that I recognize.

.diane arbus.

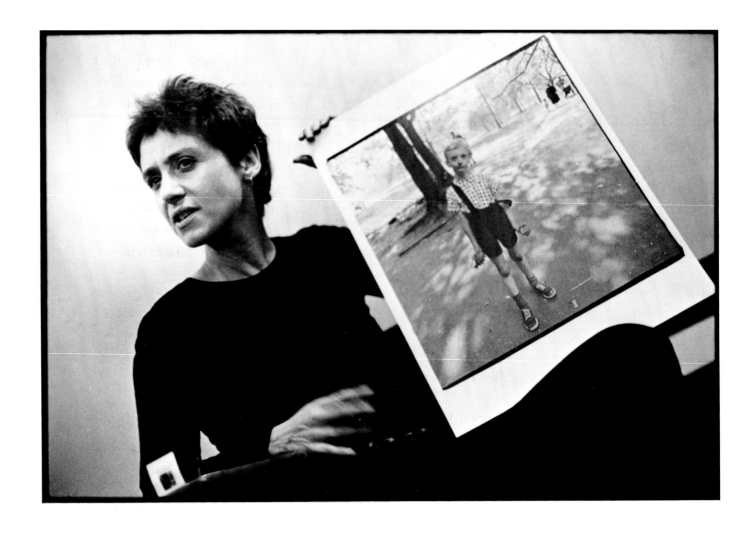

This photograph of Diane Arbus was taken by Stephen Frank during a class at the Rhode Island School of Design in 1970.

My favorite thing is to go where I've never been. For me there's something about just going into somebody else's house. When it comes time to go, if I have to take a bus to somewhere or if I have to take a cab uptown, it's like I've got a blind date. It's always seemed something like that to me. And sometimes I have a sinking feeling of, Oh God it's time and I really don't want to go. And then, once I'm on my way, something terrific takes over about the sort of queasiness of it and how there's absolutely no method for control.

If I were just curious, it would be very hard to say to someone, "I want to come to your house and have you talk to me and tell me the story of your life." I mean people are going to say, "You're crazy." Plus they're going to keep mighty guarded. But the camera is a kind of license. A lot of people, they want to be paid that much attention and that's a reasonable kind of attention to be paid.

Actually, they tend to like me. I'm extremely likeable with them. I think I'm kind of two-faced. I'm very ingratiating. It really kind of annoys me. I'm just sort of a little too nice. Everything is Oooo. I hear myself saying, "How terrific," and there's this woman making a face. I really *mean* it's terrific. I don't mean I wish I looked like that. I don't mean I wish my children looked like that. I don't mean in my private life I want to kiss you. But I mean that's amazingly, undeniably something.

There are always two things that happen. One is recognition and the other is that it's totally peculiar. But there's some sense in which I always identify with them.

Everybody has that thing where they need to look one way but they come out looking another way and that's what people observe. You see someone on the street and essentially what you notice about them is the flaw. It's just extraordinary that we should have been given these peculiarities. And, not content with what we were given, we create a whole other set. Our whole guise is like giving a sign

to the world to think of us in a certain way but there's a point between what you want people to know about you and what you can't help people knowing about you. And that has to do with what I've always called the gap between intention and effect. I mean if you scrutinize reality closely enough, if in some way you really, really get to it, it becomes fantastic. You know it really is totally fantastic that we look like this and you sometimes see that very clearly in a photograph. Something is ironic in the world and it has to do with the fact that what you intend never comes out like you intend it.

What I'm trying to describe is that it's impossible to get out of your skin into somebody else's. And that's what all this is a little bit about. That somebody else's tragedy is not the same as your own.

Another thing is a photograph has to be specific. I remember a long time ago when I first began to photograph I thought, There are an awful lot of people in the world and it's going to be terribly hard to photograph all of them, so if I photograph some kind of generalized human being, everybody'll recognize it. It'll be like what they used to call the common man or something. It was my teacher, Lisette Model, who finally made it clear to me that the more specific you are, the more general it'll be. You really have to face that thing. And there are certain evasions, certain nicenesses that I think you have to get out of.

The process itself has a kind of exactitude, a kind of scrutiny that we're not normally subject to. I mean that we don't subject each other to. We're nicer to each other than the intervention of the camera is going to make us. It's a little bit cold, a little bit harsh.

Now, I don't mean to say that all photographs have to be mean. Sometimes they show something really nicer in fact than what you felt, or oddly different. But in a way this scrutiny has to do with

not evading facts, not evading what it really looks like.

Freaks was a thing I photographed a lot. It was one of the first things I photographed and it had a terrific kind of excitement for me. I just used to adore them. I still do adore some of them. I don't quite mean they're my best friends but they made me feel a mixture of shame and awe. There's a quality of legend about freaks. Like a person in a fairy tale who stops you and demands that you answer a riddle. Most people go through life dreading they'll have a traumatic experience. Freaks were born with their trauma. They've already passed their test in life. They're aristocrats.

I'm very little drawn to photographing people that are known or even subjects that are known. They fascinate me when I've barely heard of them and the minute they get public, I become terribly blank about them.

Sometimes I can see a photograph or a painting, I see it and I think, That's not the way it is. I don't mean a feeling of, I don't like it. I mean the feeling that this is fantastic, but there's something wrong. I guess it's my own sense of what a fact is. Something will come up in me very strongly of No, a terrific No. It's a totally private feeling I get of how different it really is.

I'm not saying I get it only from pictures I don't like. I also get it from pictures I like a lot. You come outdoors and all you've got is you and all photographs begin to fall away and you think, My God, it's really totally different. I don't mean you can do it precisely like it is, but you can do it more like it is.

I used to have this notion when I was a kid that the minute you said anything, it was no longer true. Of course it would have driven me crazy very rapidly if I hadn't dropped it, but there's something

similar in what I'm trying to say. That once it's been done, you want to go someplace else. There's just some sense of straining.

Nudist camps was a terrific subject for me. I've been to three of them over a period of years. The first time I went was in 1963 when I stayed a whole week and that was really thrilling. It was the seediest camp and for that reason, for some reason, it was also the most terrific. It was really falling apart. The place was mouldy and the grass wasn't growing.

I had always wanted to go but I sort of didn't dare tell anybody. The director met me at the bus station because I didn't have a car so I got in his car and I was very nervous. He said, "I hope you realize you've come to a nudist camp." Well, I hope I realized I had. So we were in total agreement there. And then he gave me this speech saying, "You'll find the moral tone here is higher than that of the outside world." His rationale for this had to do with the fact that the human body is really not as beautiful as it's cracked up to be and when you look at it, the mystery is taken away.

They have these rules. I remember at one place there were two grounds for expulsion. A man could get expelled if he got an erection or either sex could get expelled for something like staring. They had a phrase for it. I mean you were allowed to look at people but you weren't allowed to somehow make a big deal of it.

It's a little bit like walking into an hallucination without being quite sure whose it is. I was really flabbergasted the first time. I had never seen that many men naked, I had never seen that many people naked all at once. The first man I saw was mowing his lawn.

You think you're going to feel a little silly walking around with nothing on but your camera. But that

part is really sort of fun. It just takes a minute, you learn how to do it, and then you're a nudist. You may think you're not but you are.

They seem to wear more clothes than other people. I mean the men wear shoes and socks when they go down to the lake and they have their cigarettes tucked into their socks. And the women wear earrings, hats, bracelets, watches, high heels. Sometimes you'll see someone with nothing on but a bandaid.

After a while you begin to wonder. I mean there'll be an empty pop bottle or a rusty bobby pin underfoot, the lake bottom oozes mud in a particularly nasty way, the outhouse smells, the woods look mangy. It gets to seem as if way back in the Garden of Eden after the Fall, Adam and Eve had begged the Lord to forgive them and He, in his boundless exasperation had said, "All right, then. Stay. Stay in the Garden. Get civilized. Procreate. Muck it up." And they did.

One of the things I felt I suffered from as a kid was I never felt adversity. I was confirmed in a sense of unreality which I could only feel as unreality. And the sense of being immune was, ludicrous as it seems, a painful one. It was as if I didn't inherit my own kingdom for a long time. The world seemed to me to belong to the world. I could learn things but they never seemed to be my own experience.

I wasn't a child with tremendous yearnings. I didn't worship heroes. I didn't long to play the piano or anything. I did paint but I hated painting and I quit right after high school because I was continually told how terrific I was. It was like self-expression time and I was in a private school and their tendency was to say, "What would you like to do?" And then you did something and they said, "How terrific." It made me feel shaky. I remember I hated the smell of the paint and the noise it would make when I put my brush to the paper. Sometimes I wouldn't really look but just listen to

this horrible sort of squish squish squish. I didn't want to be told I was terrific. I had the sense that if I was so terrific at it, it wasn't worth doing.

It's always seemed to me that photography tends to deal with facts whereas film tends to deal with fiction. The best example I know is when you go to the movies and you see two people in bed, you're willing to put aside the fact that you perfectly well know that there was a director and a cameraman and assorted lighting people all in that same room and the two people in bed weren't really alone. But when you look at a photograph, you can never put that aside.

A whore I once knew showed me a photo album of Instamatic color pictures she'd taken of guys she'd picked up. I don't mean kissing ones. Just guys sitting on beds in motel rooms. I remember one of a man in a bra. He was just a man, the most ordinary, milktoast sort of man, and he had just tried on a bra. Like anybody would try on a bra, like anybody would try on what the other person had that he didn't have. It was heartbreaking. It was really a beautiful photograph.

There've been a couple of times that I've had an experience that's absolutely like a photograph to me even though it's totally non-visual. I don't know if I can describe it. There was one that was sensational. I had gone to a dance for handicapped people. I didn't have my camera. At first I'd come in and I was incredibly bored. I was sort of holding myself very in and really dreading the whole evening. I couldn't photograph and there wasn't even much I wanted to photograph. There were all different kinds of handicapped people. In fact, one woman told me this terrific thing which was that the cerebral palsies don't like the polios and they both dislike the retardeds. Anyway, after a while somebody asked me to dance and then I danced with a number of people. I began to have an absolutely sensational time. I can't really explain it. One sort of unpleasant aspect of it was that it

was a little bit like being Jean Shrimpton all of a sudden. I mean you had this feeling that you were totally sensational suddenly because of the circumstances. Something had shifted and suddenly you were a remarkable creature. But the other thing was that my whole relation to people changed and I really had the most marvelous time.

Then the woman who had brought me pointed out this man. She said, "Look at that man. He's dying to dance with somebody but he's afraid." He was a sixty year old man and he was retarded and visually he was not interesting to me at all because there was nothing about him that looked strange. He just looked like any sixty year old man. He just looked sort of ordinary. We started to dance and he was very shy. In fact there was something about him that was left over from being eleven. I asked him where he lived and he told me he lived in Coney Island with his father who was eighty and I asked him if he worked and he said in the summer he sold Good Humors. And then he said this incredible sentence. It was something like, "I used to worry about"—it was very slow—"I used to worry about being like this. Not knowing more. But now"—and his eyes sort of lit up—"now I don't worry anymore." Well, it was just totally knockout for me.

I like to put things up around my bed all the time, pictures of mine that I like and other things and I change it every month or so. There's some funny subliminal thing that happens. It isn't just looking at it. It's looking at it when you're not looking at it. It really begins to act on you in a funny way.

I suppose a lot of these observations are bound to be after the fact. I mean they're nothing you can do to yourself to get yourself to work. You can't make yourself work by putting up something beautiful on the wall or by knowing yourself. Very often knowing yourself isn't really going to lead you

anywhere. Sometimes it's going to leave you kind of blank. Like, here I am, there is a me, I've got a history, I've got things that are mysterious to me in the world, I've got things that bug me in the world. But there are moments when all that doesn't seem to avail.

Another thing I've worked from is reading. It happens very obliquely. I don't mean I read something and rush out and make a picture of it. And I hate that business of illustrating poems. But here's an example of something I've never photographed that's like a photograph to me. There's a Kafka story called "Investigations of a Dog" which I read a long, long time ago and I've read it since a number of times. It's a terrific story written by the dog and it's the real dog life of a dog.

Actually, one of the first pictures I ever took must have been related to that story because it was of a dog. This was about twenty years ago and I was living in the summer on Martha's Vineyard. There was a dog that came at twilight every day. A big dog. Kind of a mutt. He had sort of Weimaraner eyes, grey eyes. I just remember it was very haunting. He would come and just stare at me in what seemed a very mythic way. I mean a dog, not barking, not licking, just looking right through you. I don't think he liked me. I did take a picture of him but it wasn't very good.

I don't particularly like dogs. Well, I love stray dogs, dogs who don't like people. And that's the kind of dog picture I would take if I ever took a dog picture.

One thing I would never photograph is dogs lying in the mud.

In the beginning of photographing I used to make very grainy things. I'd be fascinated by what the grain did because it would make a kind of tapestry of all these little dots and everything would be

translated into this medium of dots. Skin would be the same as water would be the same as sky and you were dealing mostly in dark and light, not so much in flesh and blood.

But when I'd been working for a while with all these dots, I suddenly wanted terribly to get through there. I wanted to see the real differences between things. I'm not talking about textures. I really hate that, the idea that a picture can be interesting simply because it shows texture. I mean that just kills me. I don't see what's interesting about texture. It really bores the hell out of me. But I wanted to see the difference between flesh and material, the densities of different kinds of things: air and water and shiny. So I gradually had to learn different techniques to make it come clear. I began to get terribly hyped on clarity.

I used to have a theory about photographing. It was a sense of getting in between two actions, or in between action and repose. I don't mean to make a big deal of it. It was just like an expression I didn't see or wouldn't have seen. One of the excitements of strobe at one time was that you were essentially blind at the moment you took the picture. I mean it alters the light enormously and reveals things you don't see. In fact that's what made me really sick of it. I began to miss light like it really is and now I'm trying to get back to some kind of obscurity where at least there's normal obscurity.

Lately I've been struck with how I really love what you can't see in a photograph. An actual physical darkness. And it's very thrilling for me to see darkness again.

What's thrilling to me about what's called technique — I hate to call it that because it sounds like something up your sleeve — but what moves me about it is that it comes from some mysterious deep place. I mean it can have something to do with the paper and the developer and all that stuff, but it

comes mostly from some very deep choices somebody has made that take a long time and keep haunting them.

Invention is mostly this kind of subtle, inevitable thing. People get closer to the beauty of their invention. They get narrower and more particular in it. Invention has a lot to do with a certain kind of light some people have and with the print quality and the choice of subject. It's a million choices you make. It's luck in a sense, or even ill luck. Some people hate a certain kind of complexity. Others only want that complexity. But none of that is really intentional. I mean it comes from your nature, your identity. We've all got an identity. You can't avoid it. It's what's left when you take everything else away. I think the most beautiful inventions are the ones you don't think of.

Some pictures are tentative forays without your even knowing it. They become methods. It's important to take bad pictures. It's the bad ones that have to do with what you've never done before. They can make you recognize something you hadn't seen in a way that will make you recognize it when you see it again.

I hate the idea of composition. I don't know what good composition is. I mean I guess I must know something about it from doing it a lot and feeling my way into it and into what I like. Sometimes for me composition has to do with a certain brightness or a certain coming to restness and other times it has to do with funny mistakes. There's a kind of rightness and wrongness and sometimes I like rightness and sometimes I like wrongness. Composition is like that.

Recently I did a picture — I've had this experience before — and I made rough prints of a number of them. There was something wrong in all of them. I felt I'd sort of missed it and I figured I'd go back. But there was one that was just totally peculiar. It was a terrible dodo of a picture. It looks to me a

little as if the lady's husband took it. It's terribly head-on and sort of ugly and there's something terrific about it. I've gotten to like it better and better and now I'm secretly sort of nutty about it.

I think the camera is something of a nuisance in a way. It's recalcitrant. It's determined to do one thing and you may want to do something else. You have to fuse what you want and what the camera wants. It's like a horse. Well, that's a bad comparison because I'm not much of a horseback rider, but I mean you get to learn what it will do. I've worked with a couple of them. One will be terrific in certain situations, or I can make it be terrific. Another will be very dumb but sometimes I kind of like that dumbness. It'll do, you know. I get a great sense that they're different from me. I don't feel that total identity with the machine. I mean I can work it fine, although I'm not so great actually. Sometimes when I'm winding it, it'll get stuck or something will go wrong and I just start clicking everything and suddenly very often it's all right again. That's my feeling about machines. If you sort of look the other way, they'll get fixed. Except for certain ones.

There used to be this moment of panic which I still can get where I'd look in the ground glass and it would all look ugly to me and I wouldn't know what was wrong. Sometimes it's like looking in a kaleidoscope. You shake it around and it just won't shake out right. I used to think if I could jumble it up, it would all go away. But short of that, since I couldn't do that, I'd just back up or start to talk or, I don't know, go someplace else. But I don't think that's the sort of thing you can calculate on because there's always this mysterious thing in the process.

Very often when you go to photograph it's like you're going for an event. Say it's a beauty contest. You picture it in your mind a little bit, that there'll be these people who'll be the judges and they'll be choosing the winner from all these contestants and then you go there and it's not like that at all.

Very often an event happens scattered and the account of it will look to you in your mind like it's going to be very straight and photographable. But actually one person is over there and another person is over here and they don't get together. Even when you go to do a family, you want to show the whole family, but how often are the mother and father and the two kids all on the same side of the room? Unless you tell them to go there.

I work from awkwardness. By that I mean I don't like to arrange things. If I stand in front of something, instead of arranging it, I arrange myself.

I remember one summer I worked a lot in Washington Square Park. It must have been about 1966. The park was divided. It has these walks, sort of like a sunburst, and there were these territories staked out. There were young hippie junkies down one row. There were lesbians down another, really tough amazingly hard-core lesbians. And in the middle were winos. They were like the first echelon and the girls who came from the Bronx to become hippies would have to sleep with the winos to get to sit on the other part with the junkie hippies. It was really remarkable. And I found it very scary. I mean I could become a nudist, I could become a million things. But I could never become that, whatever all those people were. There were days I just couldn't work there and then there were days I could. And then, having done it a little, I could do it more. I got to know a few of them. I hung around a lot. They were a lot like sculptures in a funny way. I was very keen to get close to them, so I had to ask to photograph them. You can't get that close to somebody and not say a word, although I have done that.

I have this funny thing which is that I'm never afraid when I'm looking in the ground glass. This person could be approaching with a gun or something like that and I'd have my eyes glued to the finder and it wasn't like I was really vulnerable. It just seemed terrific what was happening. I mean

I'm sure there are limits. God knows, when the troops start advancing on me, you do approach that stricken feeling where you perfectly well can get killed.

But there's a kind of power thing about the camera. I mean everyone knows you've got some edge. You're carrying some slight magic which does something to them. It fixes them in a way.

I used to think I was shy and I got incredibly persistent in the shyness. I remember enjoying enormously the situation of being put off and having to wait. I still do. I suppose I use that waiting time for a kind of nervousness, for getting calm or, I don't know, just waiting. It isn't such a productive time. It's a really boring time. I remember once I went to this female impersonator show and I waited about four hours backstage and then I couldn't photograph and they told me to come back another night. But somehow I learned to like that experience because, while being bored I was also entranced. I mean it *was* boring, but it was also mysterious, people would pass. And also I had a sense of what there was to photograph that I couldn't actually photograph which I think is quite enjoyable sometimes.

The Chinese have a theory that you pass through boredom into fascination and I think it's true. I would never choose a subject for what it means to me or what I think about it. You've just got to choose a subject, and what you feel about it, what it means, begins to unfold if you just plain choose a subject and do it enough.

There's this person I've photographed a lot. I just saw her on the street one day. I was riding my bicycle on Third Avenue and she was with a friend of hers. They were enormous, both of them,

almost six feet tall, and fat. I thought they were big lesbians. They went into a diner and I followed them and asked if I could photograph them. They said, "Yes, tomorrow morning." Subsequently they were apparently arrested and they spent the night in jail being booked. So the next morning I got to their house around eleven and they were just coming up the stairs after me. The first thing they said was, "I think we should tell you" — I don't know why they felt so obligated — "we're men." I was very calm but I was really sort of pleased.

I got to know one of them pretty well. She lives always dressed as a woman and she whores as a woman. I would never think she was a man. I can't really see the man in her. Most of the time I absolutely know but she has none of the qualities of female impersonators that I can recognize. I have gone into restaurants with her and every man in the place has turned around to look at her and made all kinds of hoots and whistles. And it was her, it wasn't me.

The last time I saw her I went to her birthday party. She called me up and said it was her birthday party and would I come and I said, "How terrific." It was a hotel on Broadway and 100th Street. I've never been in a place like that in my life. I've been in some pretty awful places but the lobby was really like Hades. There were people lounging around with the whites of their eyes sort of purple and their faces all somehow violety black and it was scary. The elevator was broken and so finally I decided to walk. It was the fourth floor and there were these people dead on their feet on the stairs. You had to step over about three or four people every flight. And then I came into her room. The birthday party was me and her, a whore friend of hers and her pimp, and the cake.

The thing that's important to know is that you never know. You're always sort of feeling your way.

One thing that struck me very early is that you don't put into a photograph what's going to come

out. Or, vice versa, what comes out is not what you put in.

I never have taken a picture I've intended. They're always better or worse.

For me the subject of the picture is always more important than the picture. And more complicated. I do have a feeling for the print but I don't have a holy feeling for it. I really think what it is, is what it's about. I mean it has to be *of* something. And what it's of is always more remarkable than what it is.

I do feel I have some slight corner on something about the quality of things. I mean it's very subtle and a little embarrassing to me, but I really believe there are things which nobody would see unless I photographed them.

Russian midget friends in a living room on 100th Street, N.Y.C. 1963

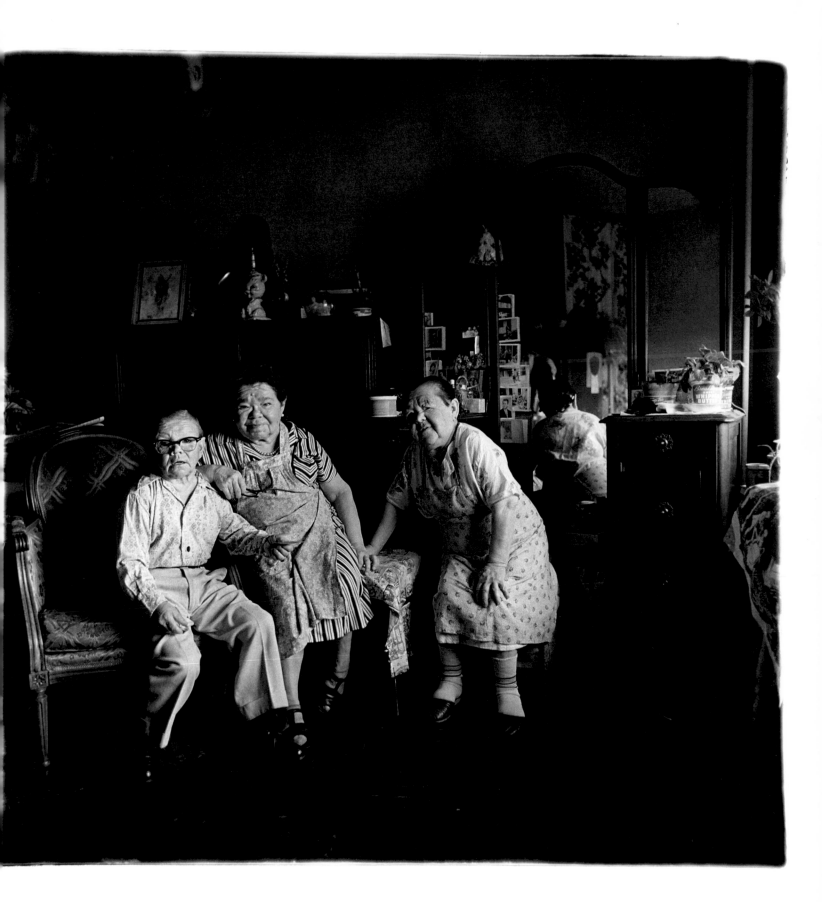

A young man in curlers at home on West 20th Street, N.Y.C. 1966

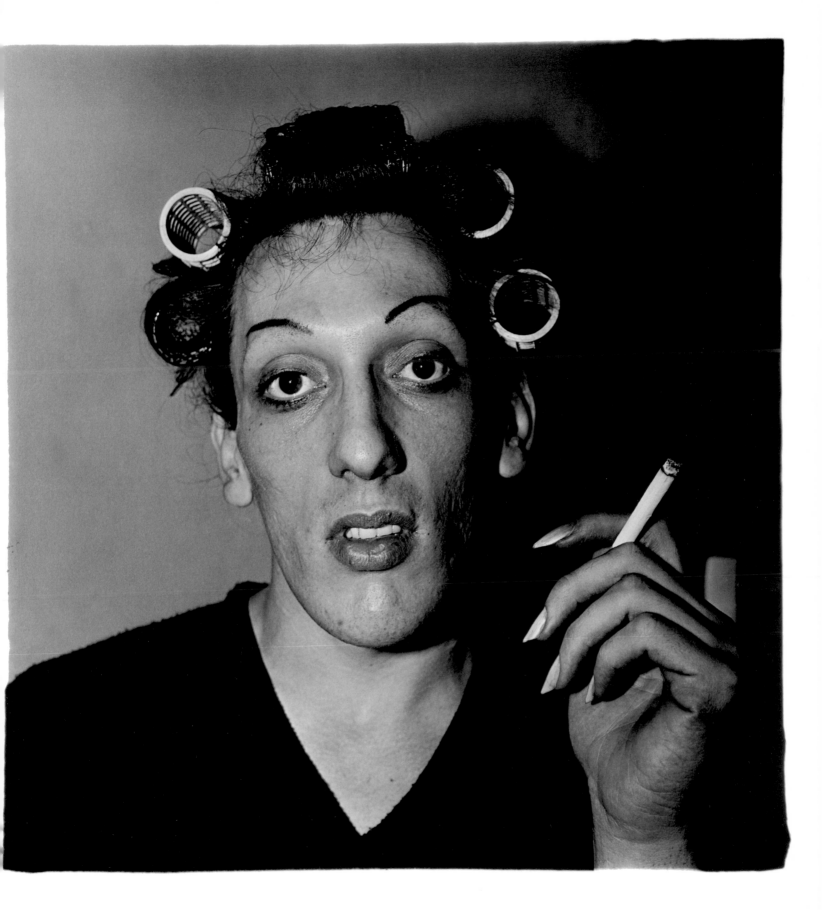

The Junior Interstate Ballroom Dance Champions, Yonkers, N.Y. 1962

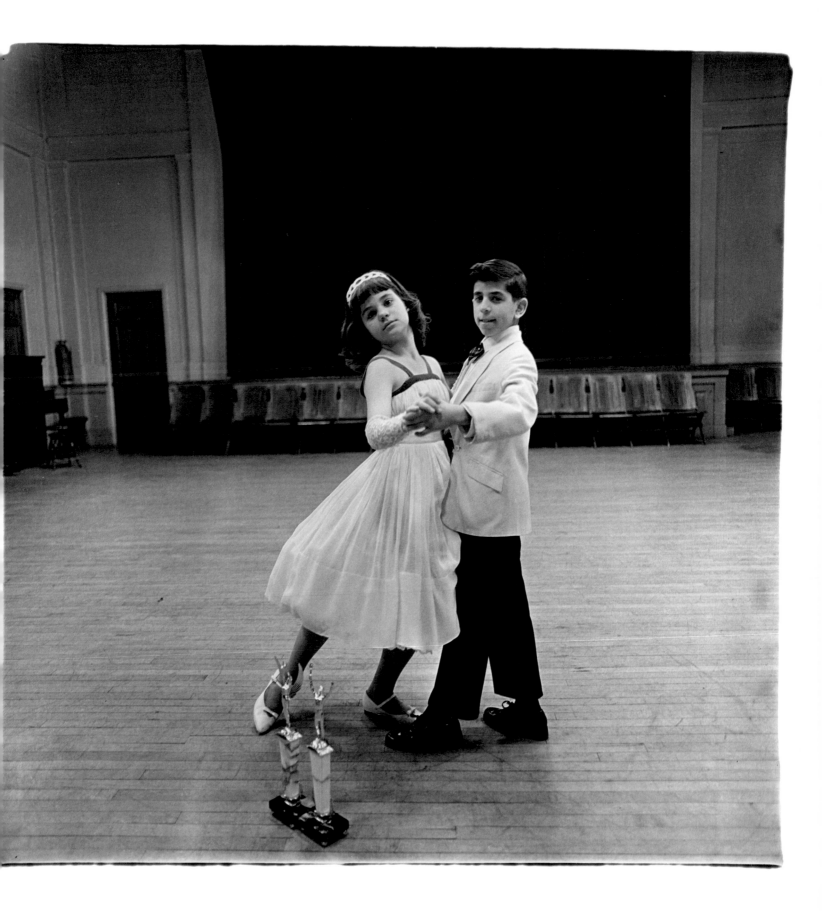

Girl with a cigar in Washington Square Park, N.Y.C. 1965

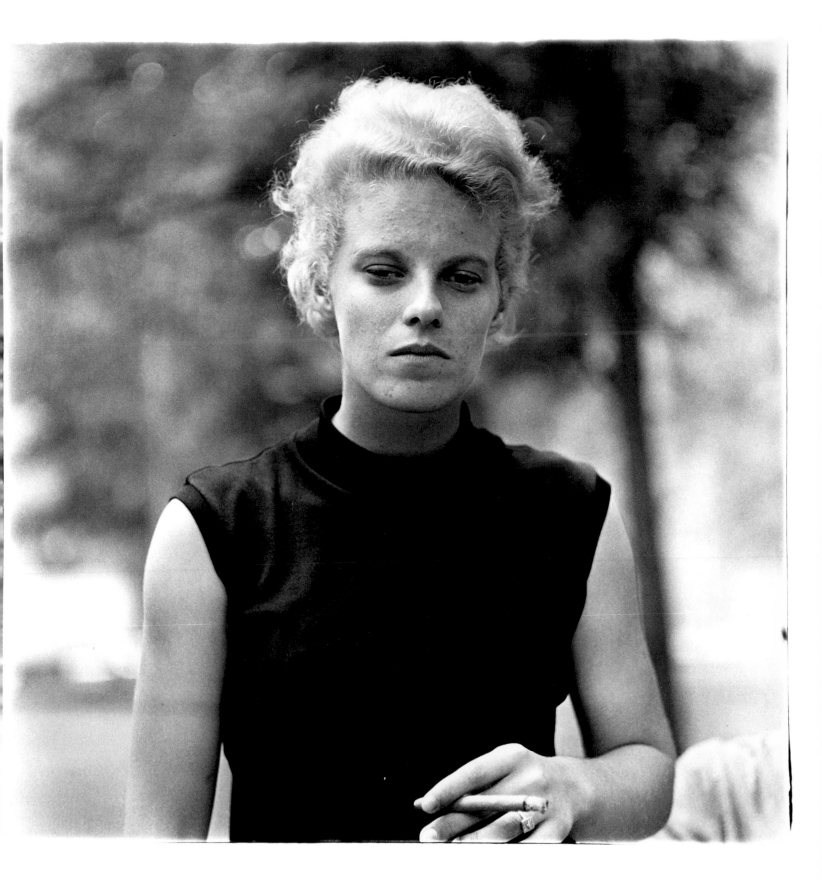

Retired man and his wife at home in a nudist camp one morning, N.J. 1963

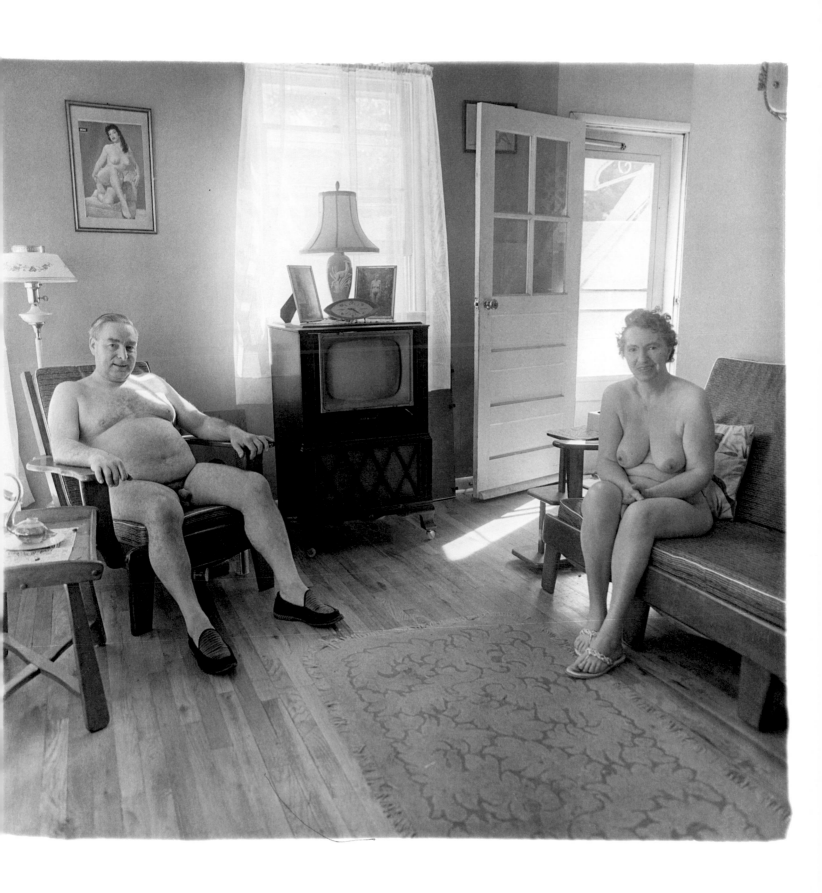

UNIV. OF ST. FRANCIS
JOLIET, ILLINOIS

Loser at a Diaper Derby, N.J. 1967

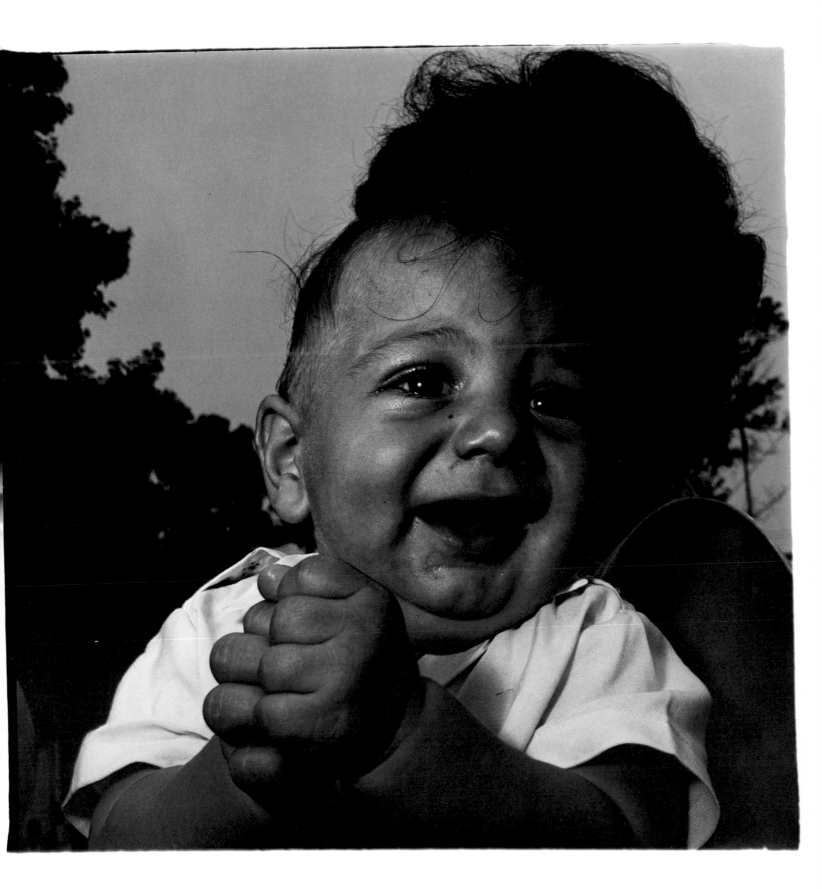

A family on their lawn one Sunday in Westchester, N.Y. 1968

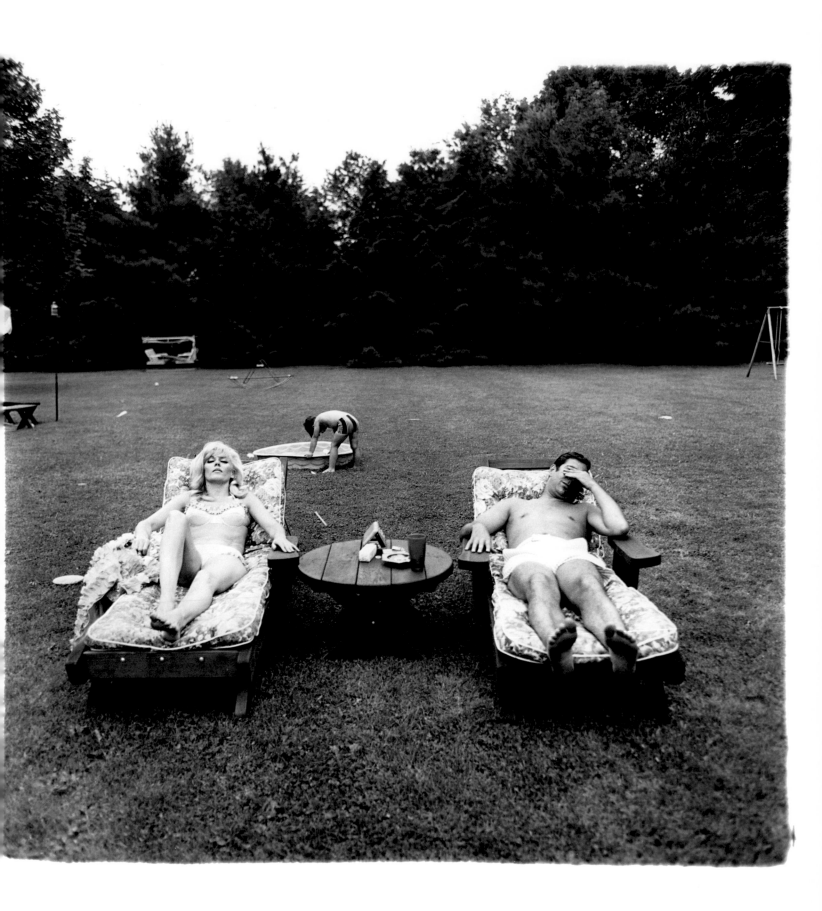

Mexican dwarf in his hotel room in N.Y.C. 1970

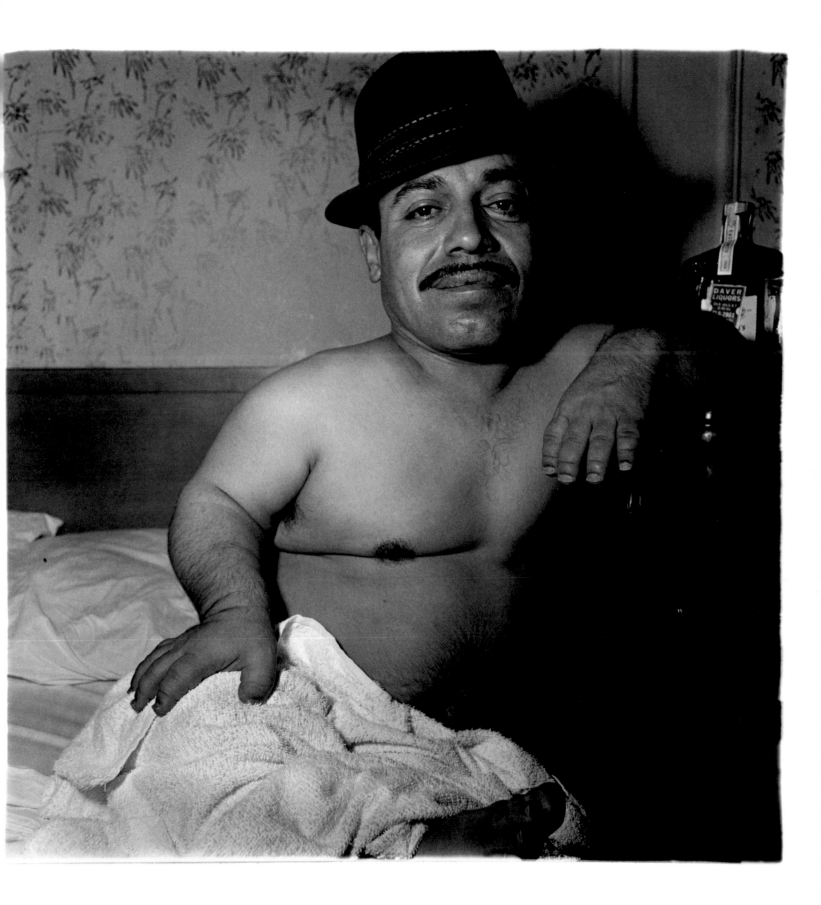

A castle in Disneyland, Cal. 1962

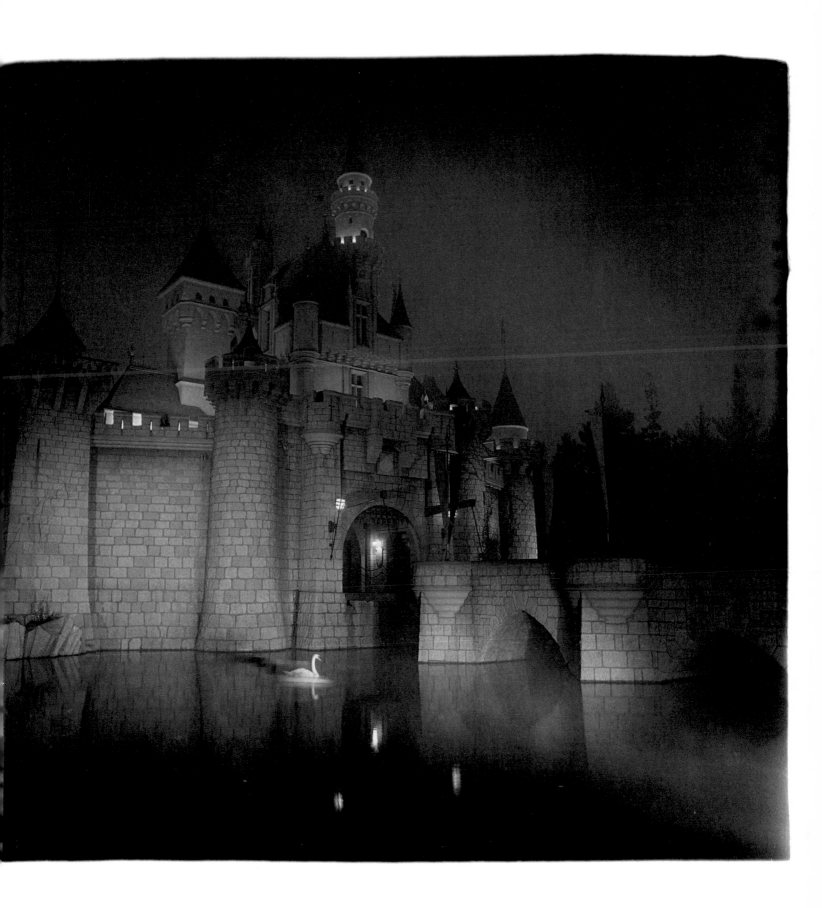

A young Brooklyn family going for a Sunday outing, N.Y.C. 1966

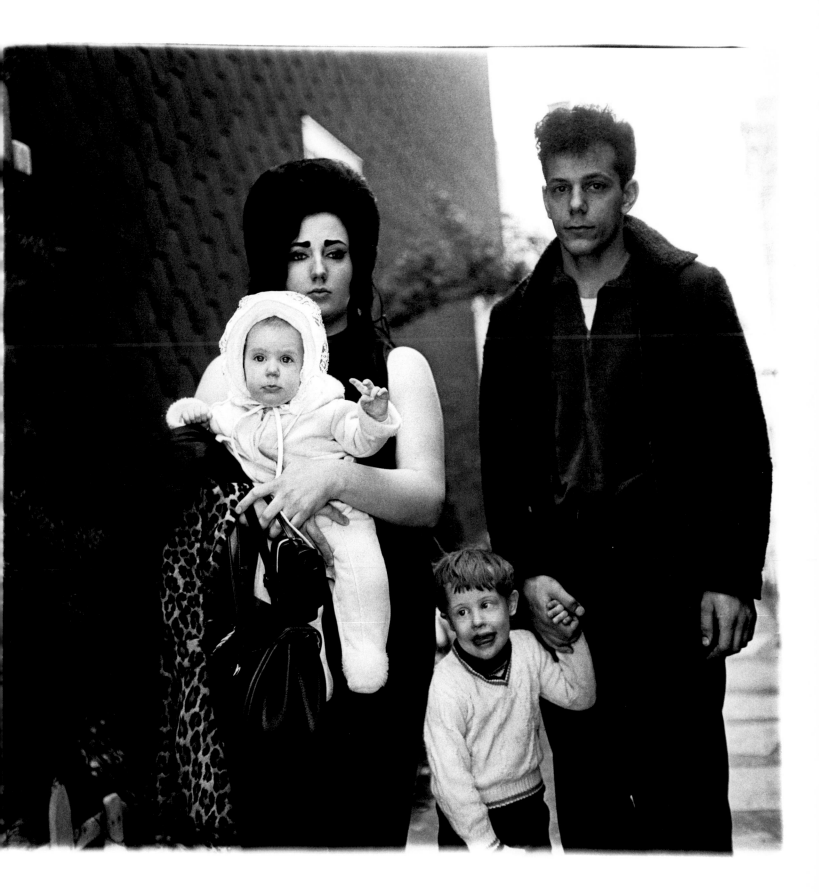

Puerto Rican woman with a beauty mark, N.Y.C. 1965

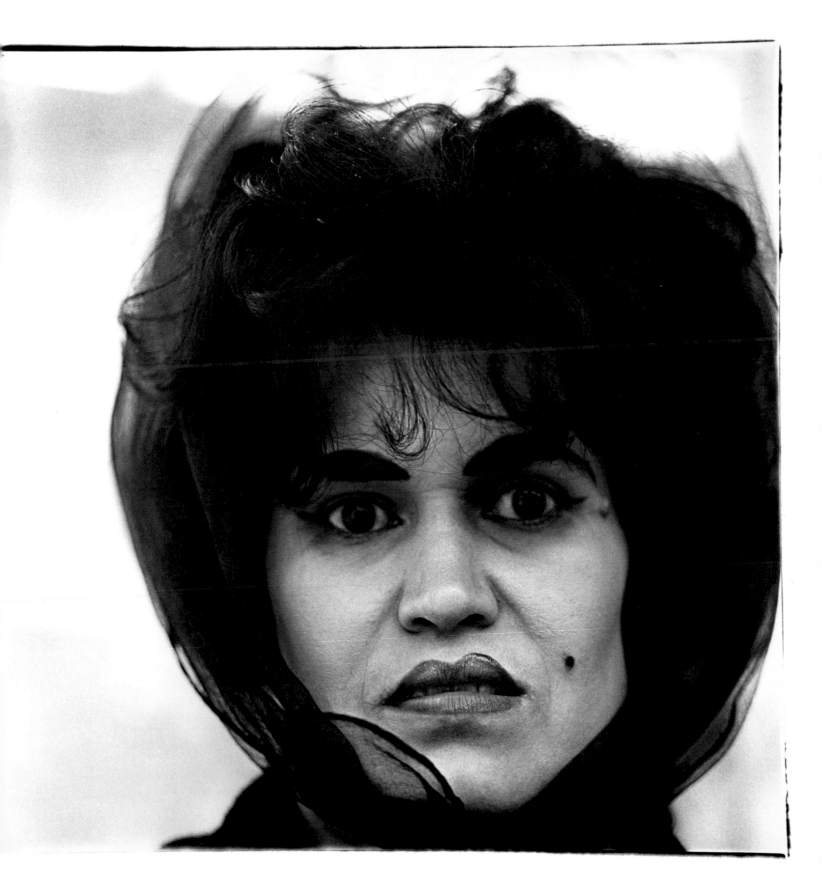

A family one evening in a nudist camp, Pa. 1965

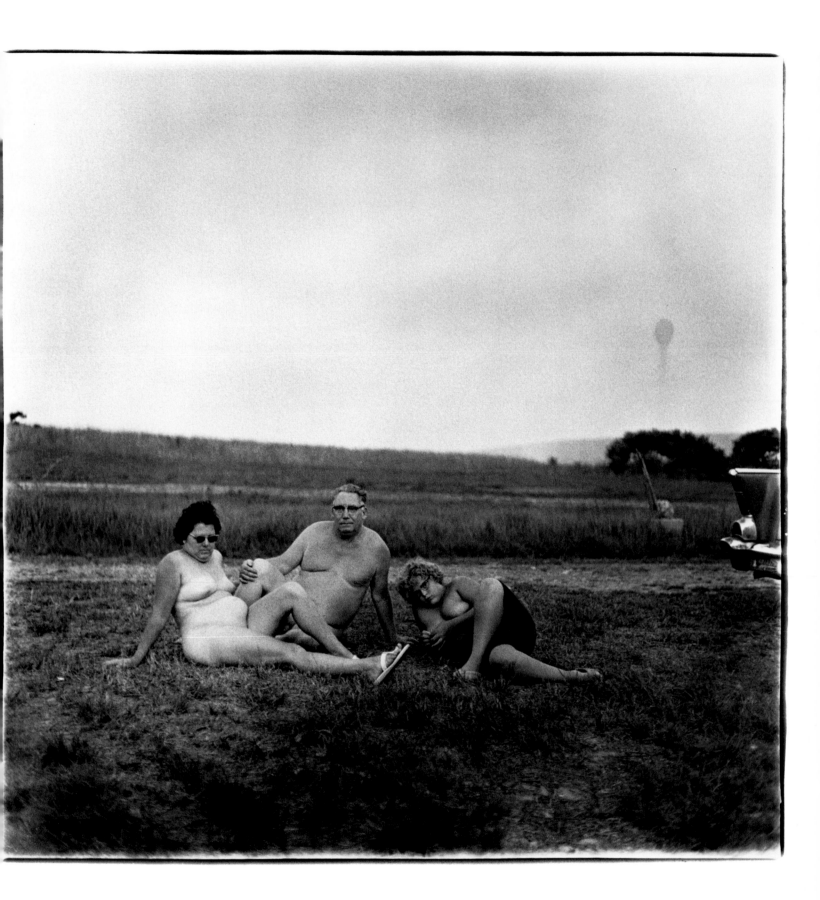

Boy with a straw hat waiting to march in a pro-war parade, N.Y.C. 1967

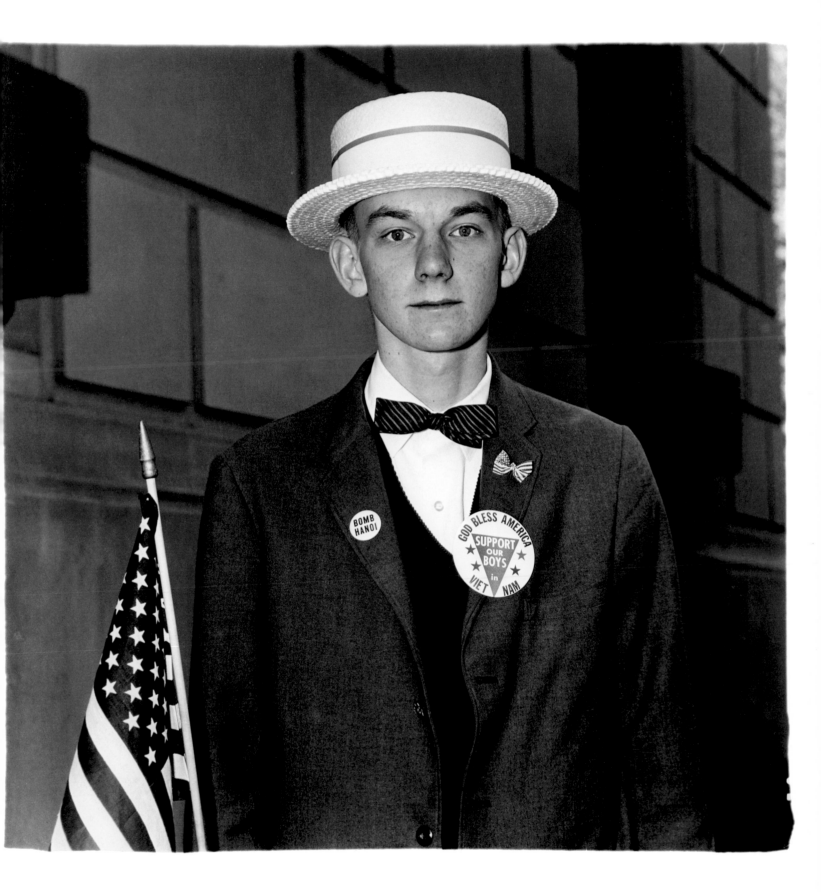

Girl in a coat lying on her bed, N.Y.C. 1968

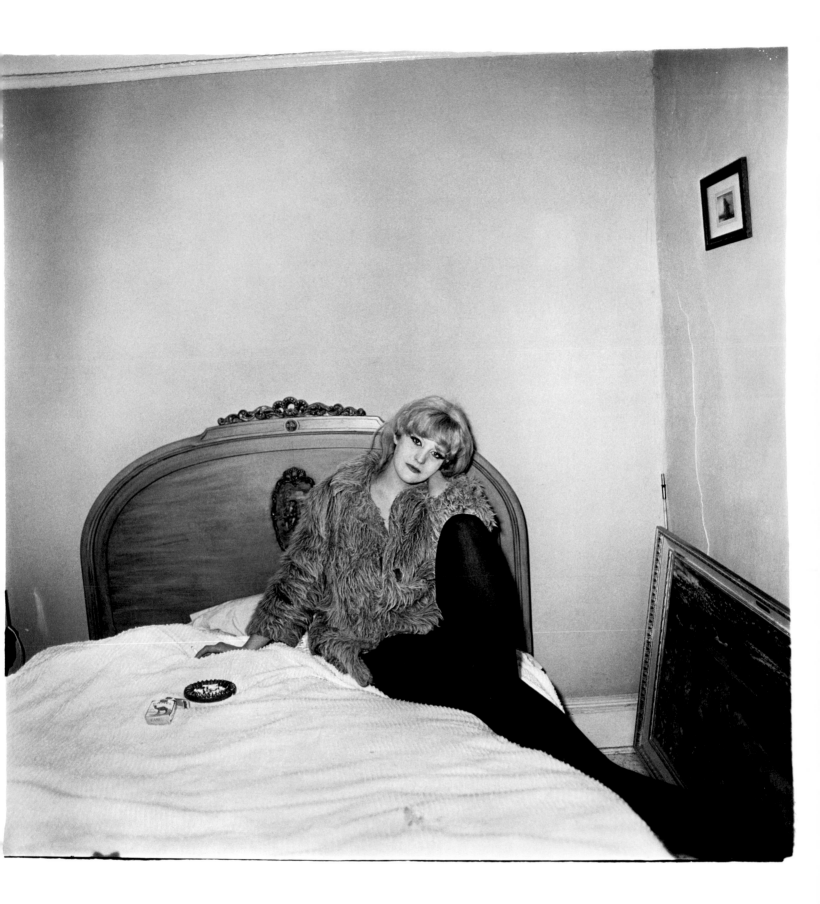

Elderly couple on a park bench, N.Y.C. 1969

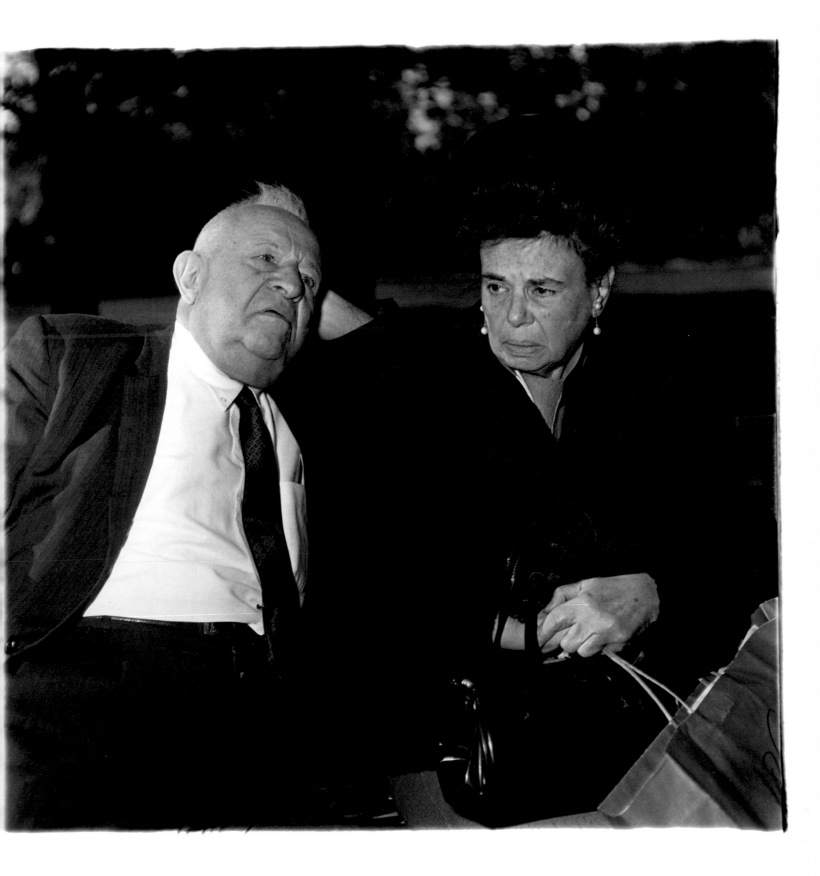

A flower girl at a wedding, Conn. 1964

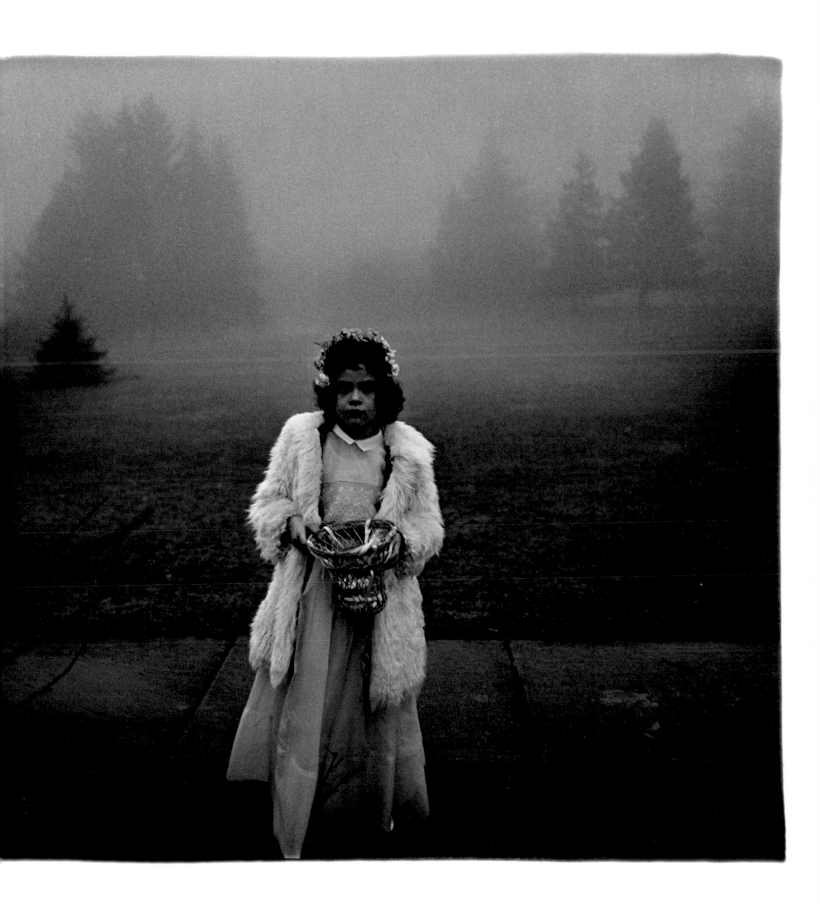

Xmas tree in a living room in Levittown, L.I. 1963

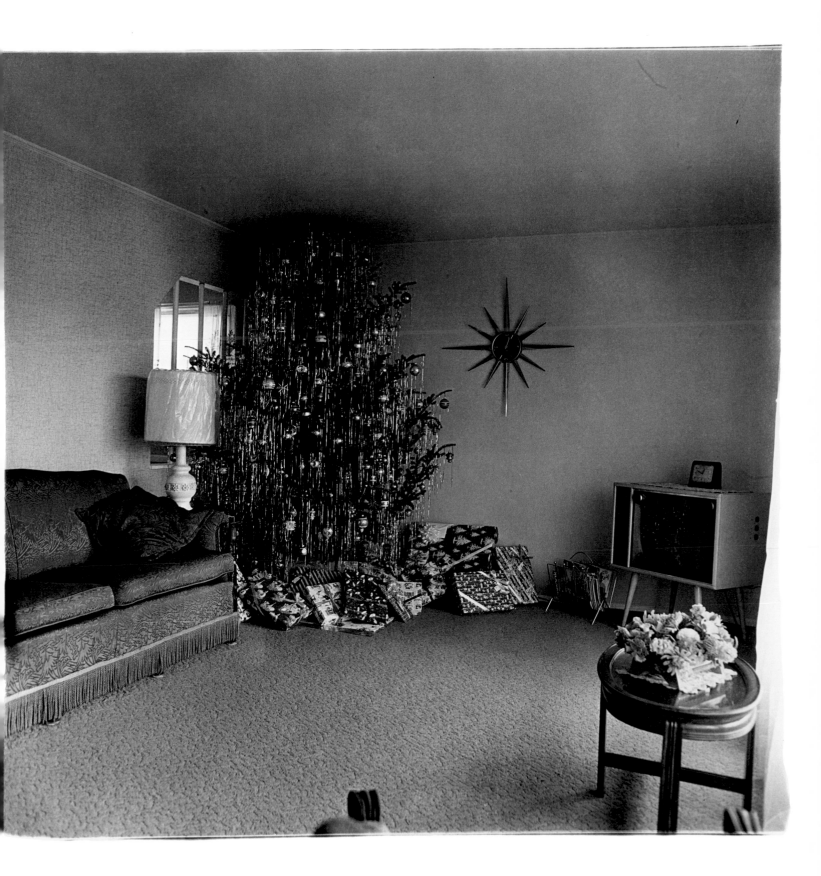

A Jewish giant at home with his parents in the Bronx, N.Y. 1970

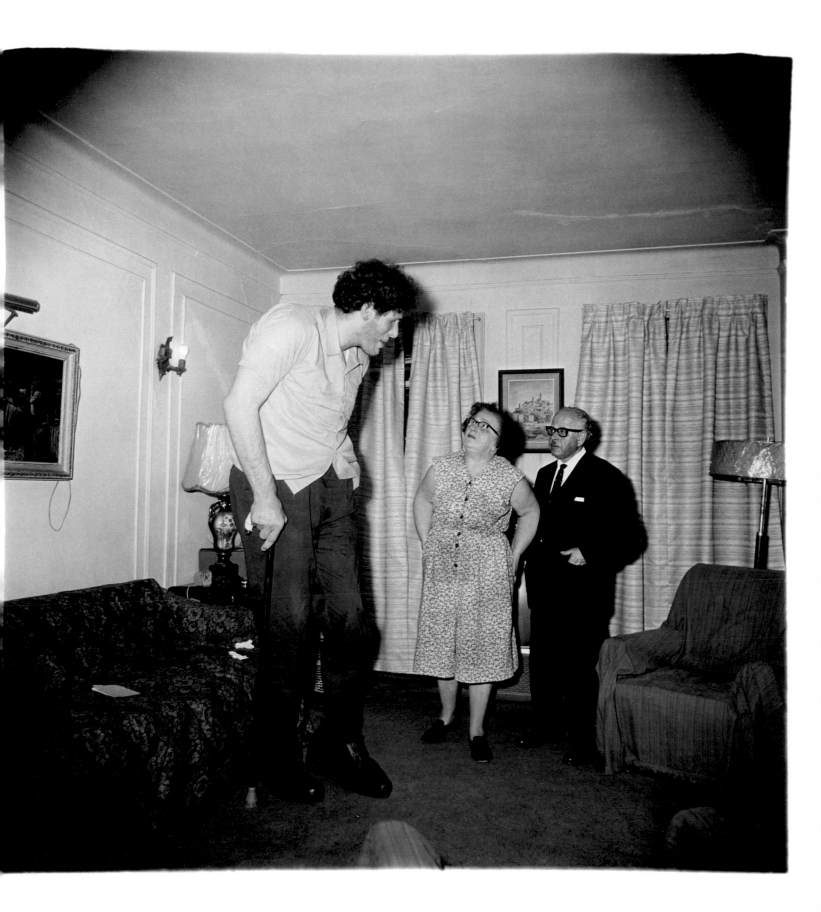

Lady at a masked ball with two roses on her dress, N.Y.C. 1967

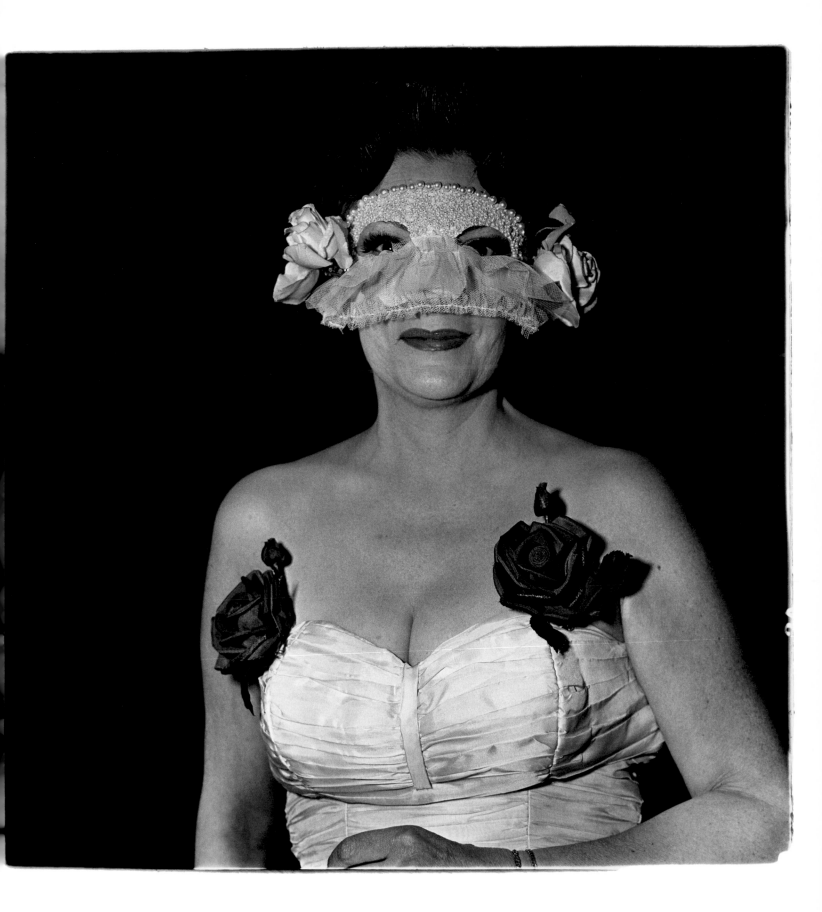

Identical twins, Roselle, N.J. 1967

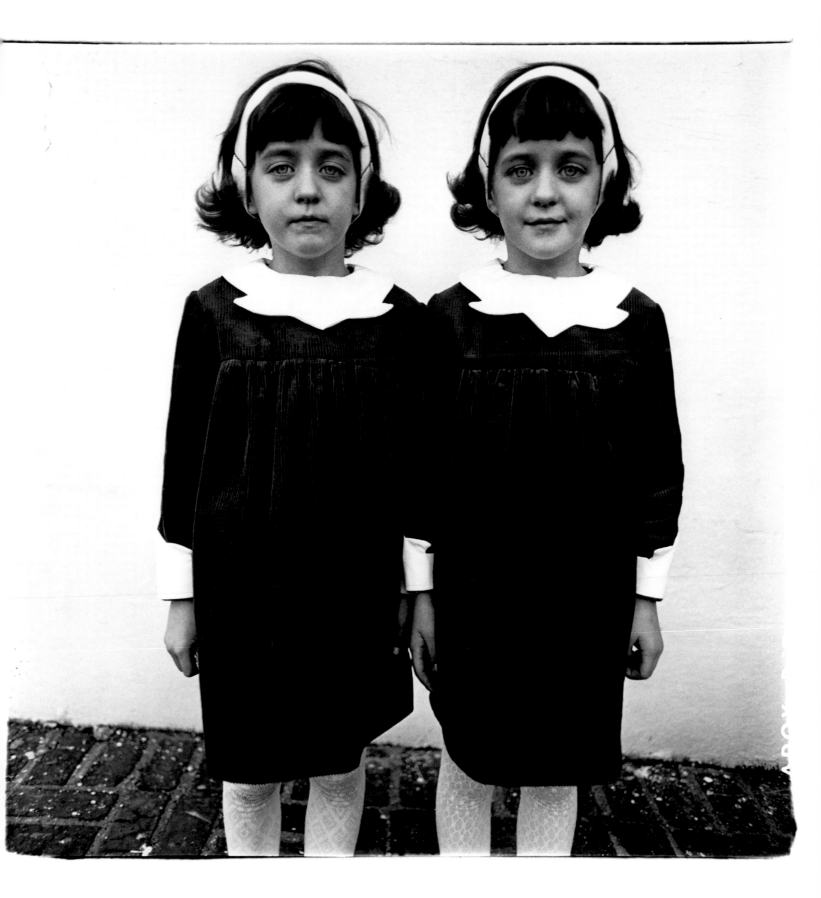

Four people at a gallery opening, N.Y.C. 1968

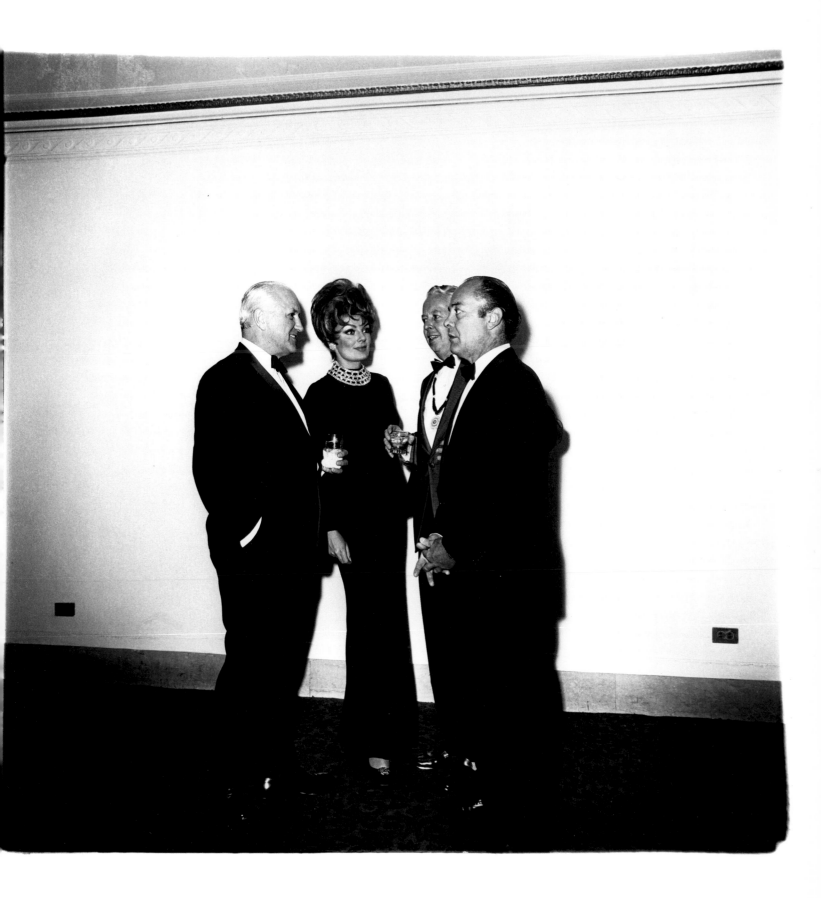

Two men dancing at a drag ball, N.Y.C. 1970

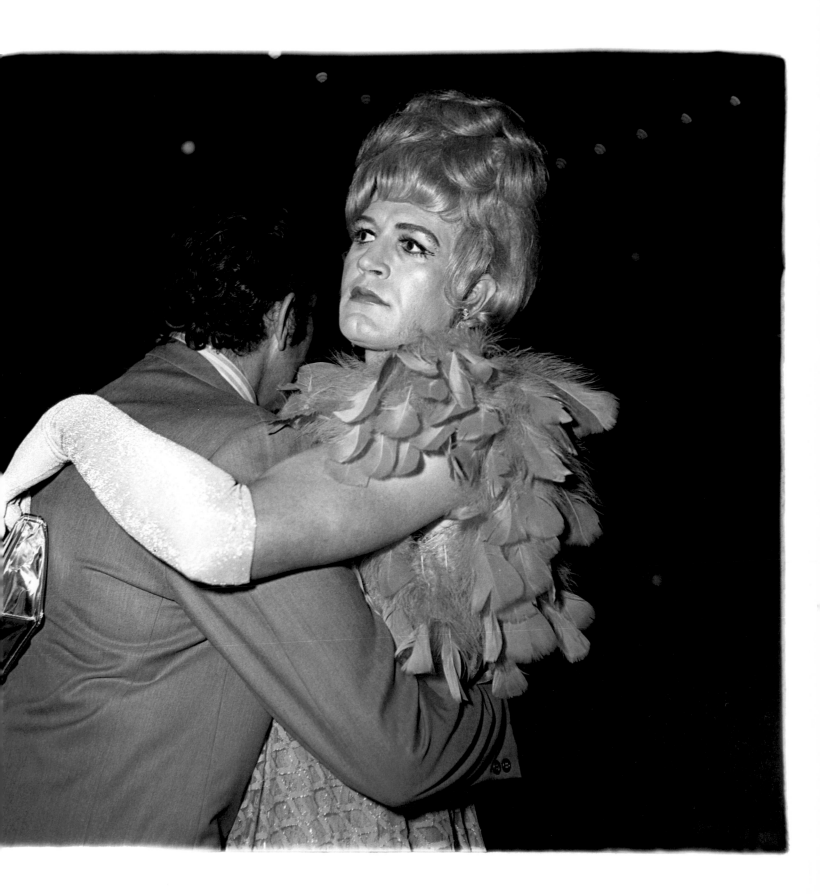

A husband and wife in the woods at a nudist camp, N.J. 1963

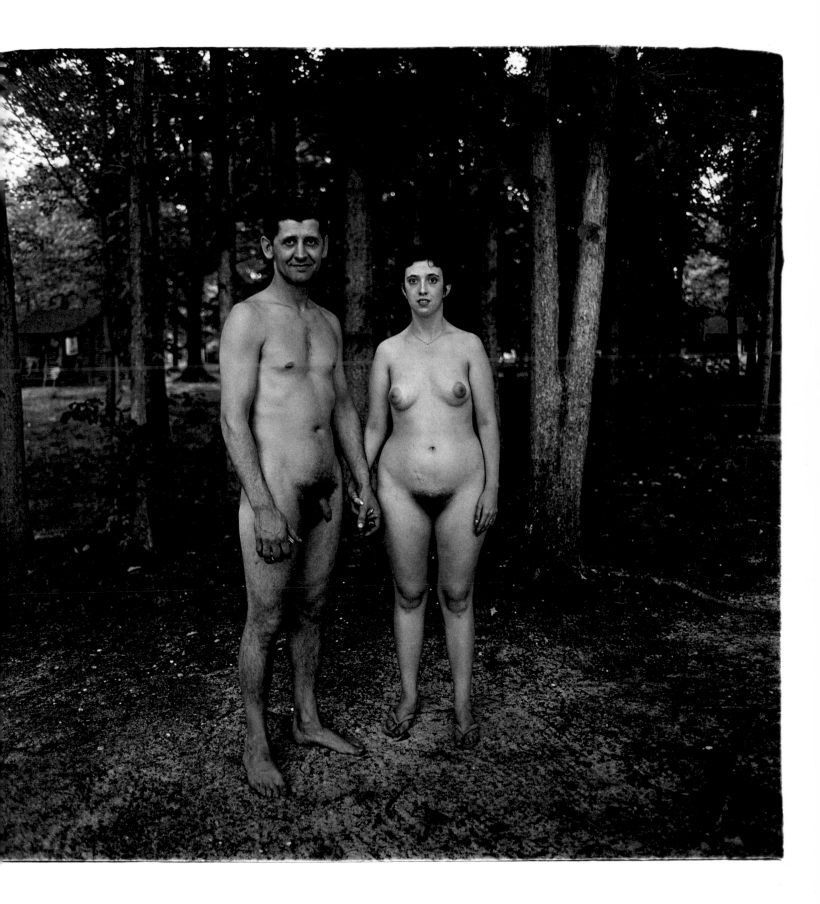

A lobby in a building, N.Y.C. 1966

A child crying, N.J. 1967

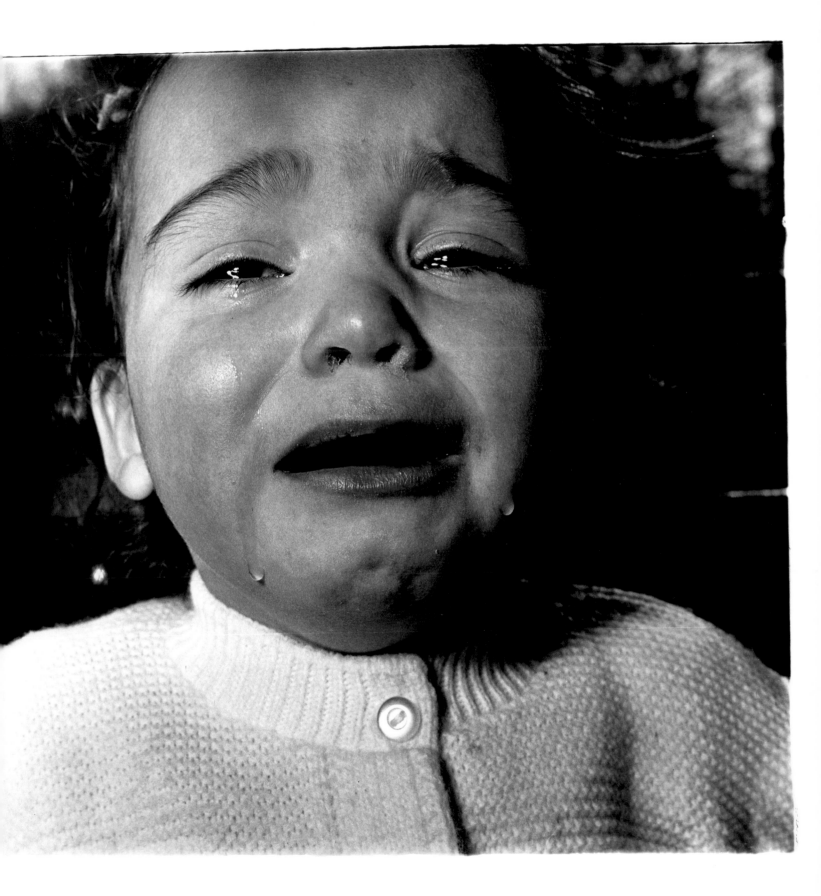

A young man and his girlfriend with hot dogs in the park, N.Y.C. 1971

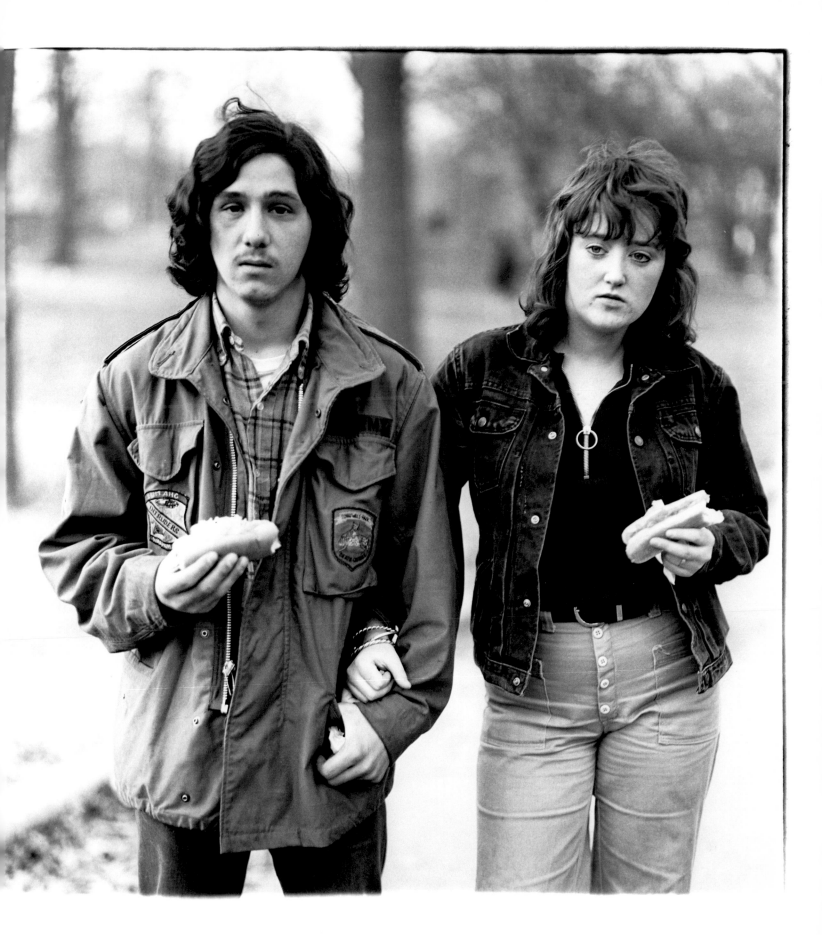

Transvestite at her birthday party, N.Y.C. 1969

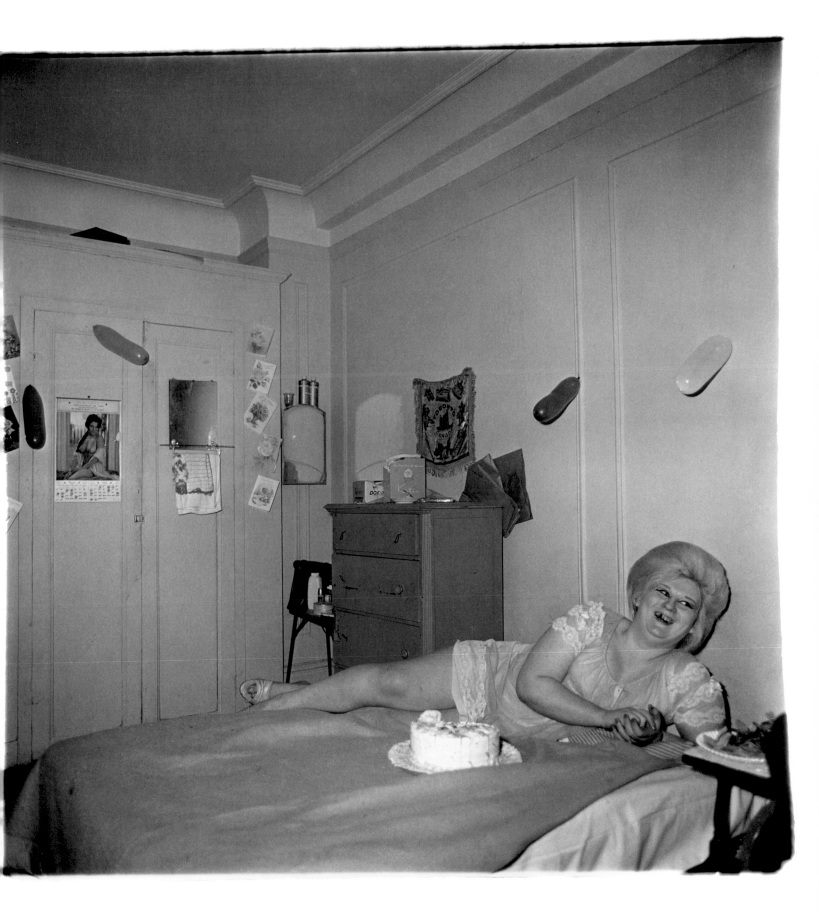

Lady in a rooming house parlor, Albion, N.Y. 1963

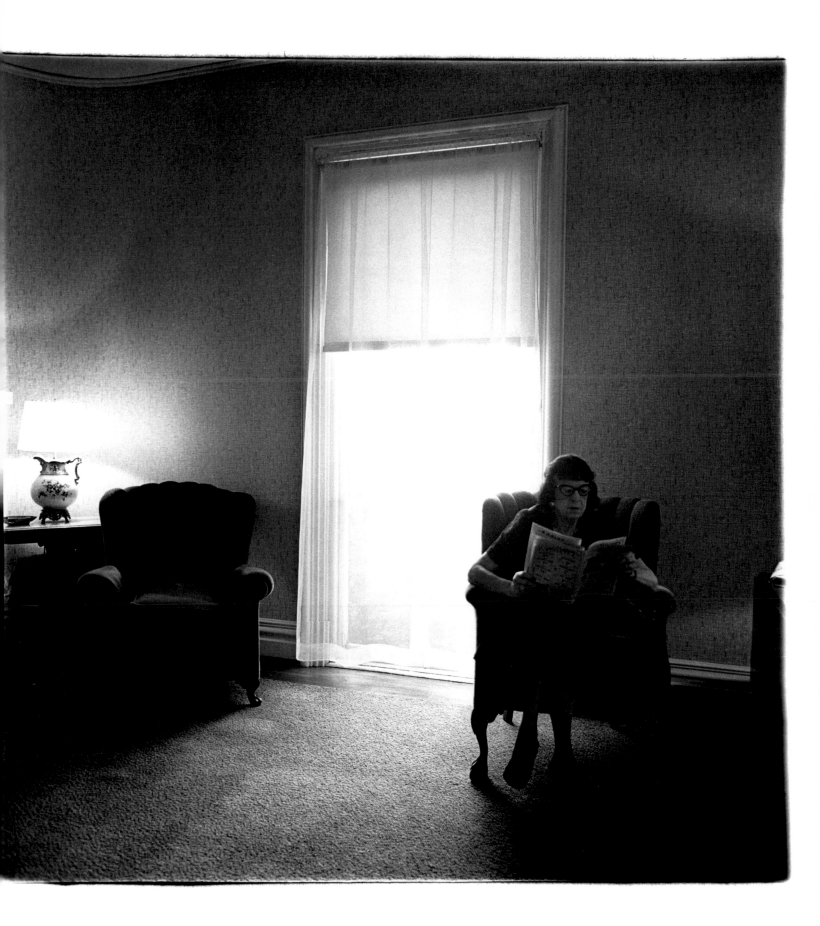

Woman with a locket in Washington Square Park, N.Y.C. 1965

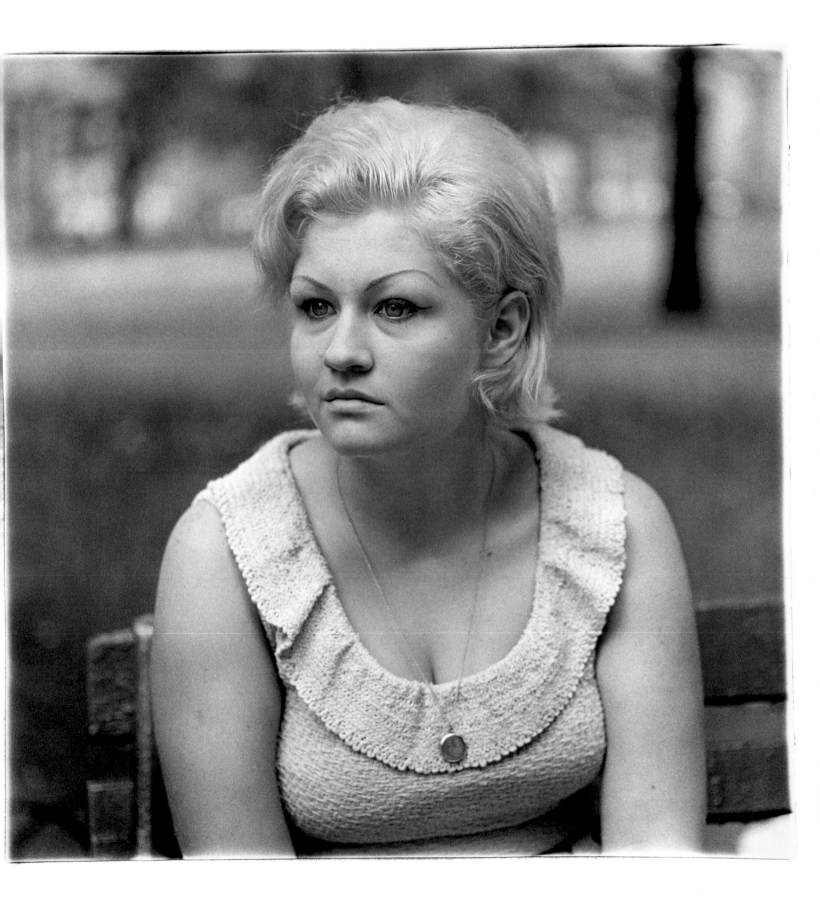

Burlesque commedienne in her dressing room, Atlantic City, N.J. 1963

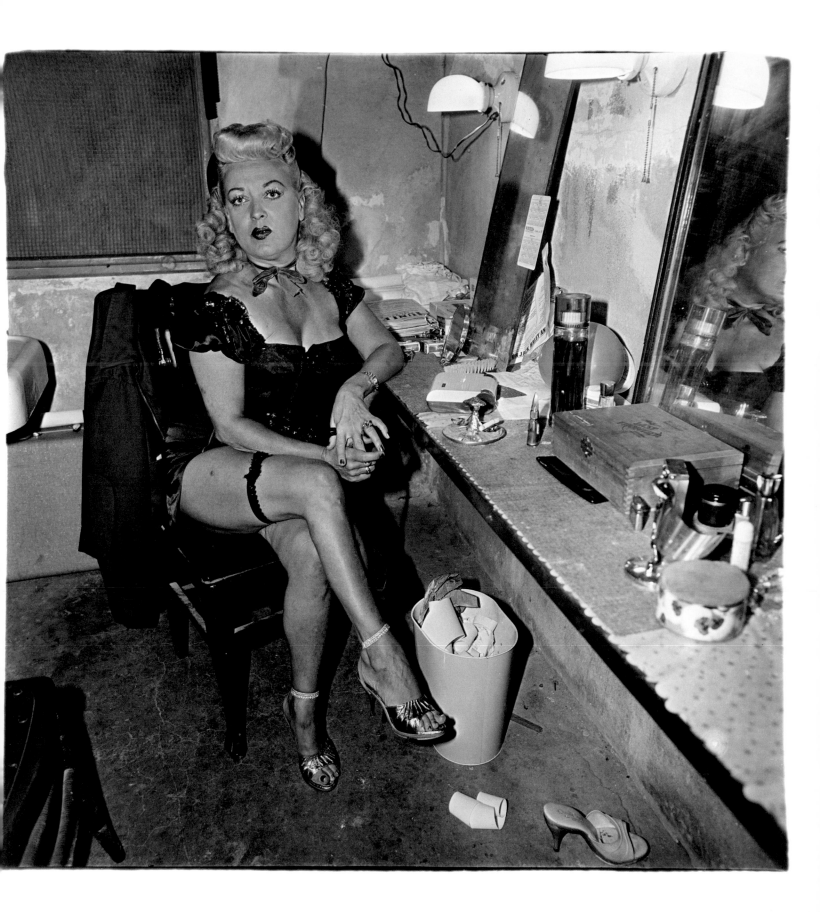

A Jewish couple dancing, N.Y.C. 1963

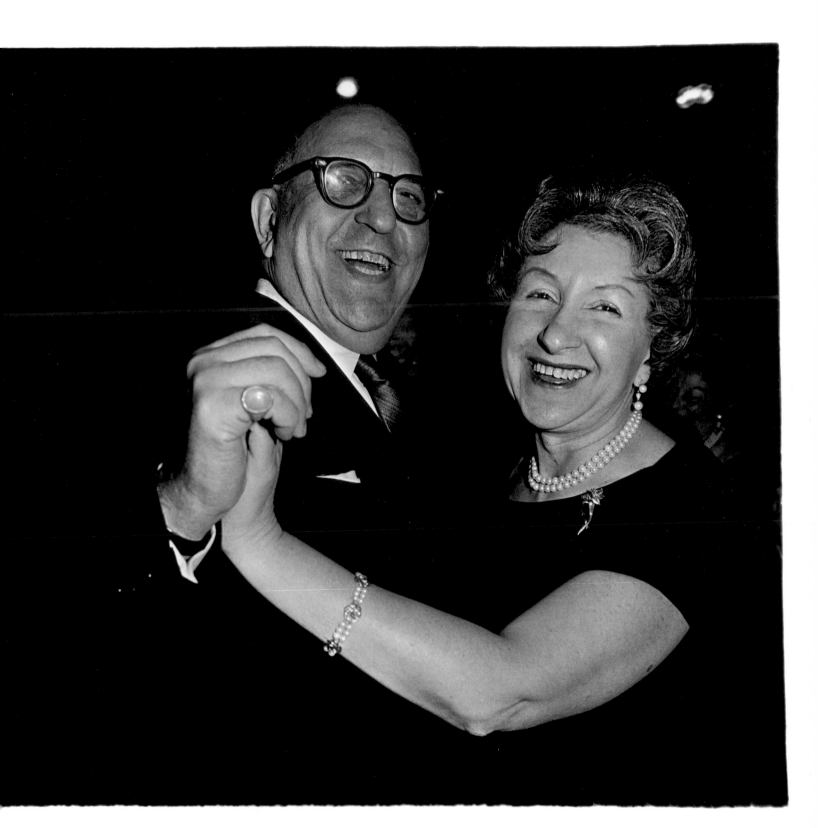

Triplets in their bedroom, N.J. 1963

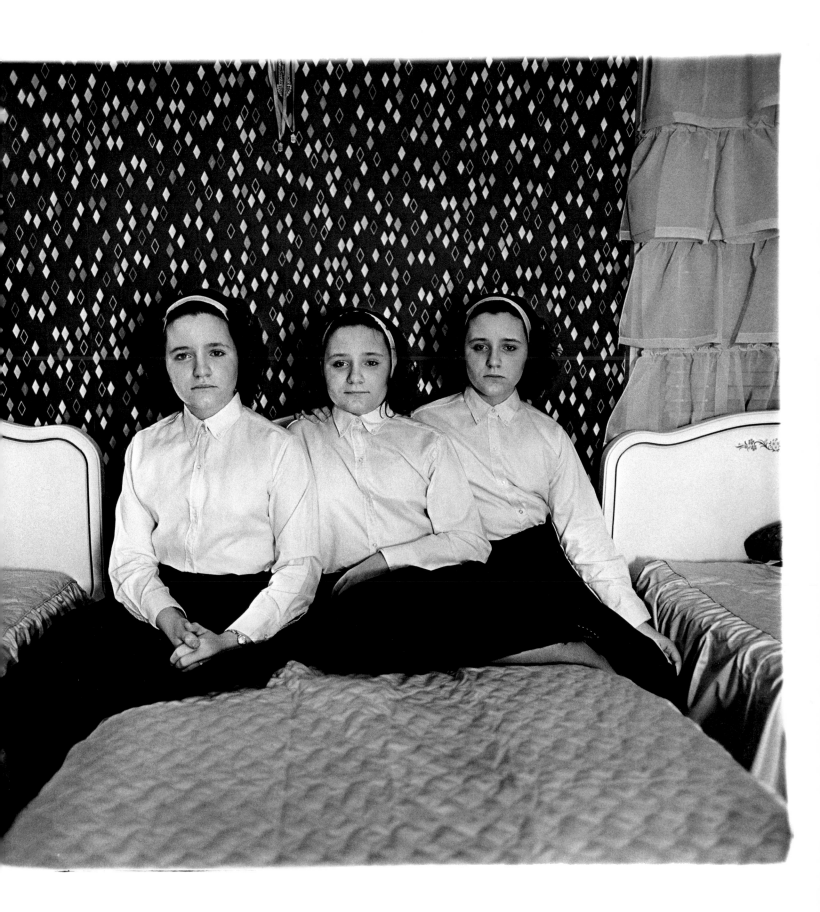

Masked man at a ball, N.Y.C. 1967

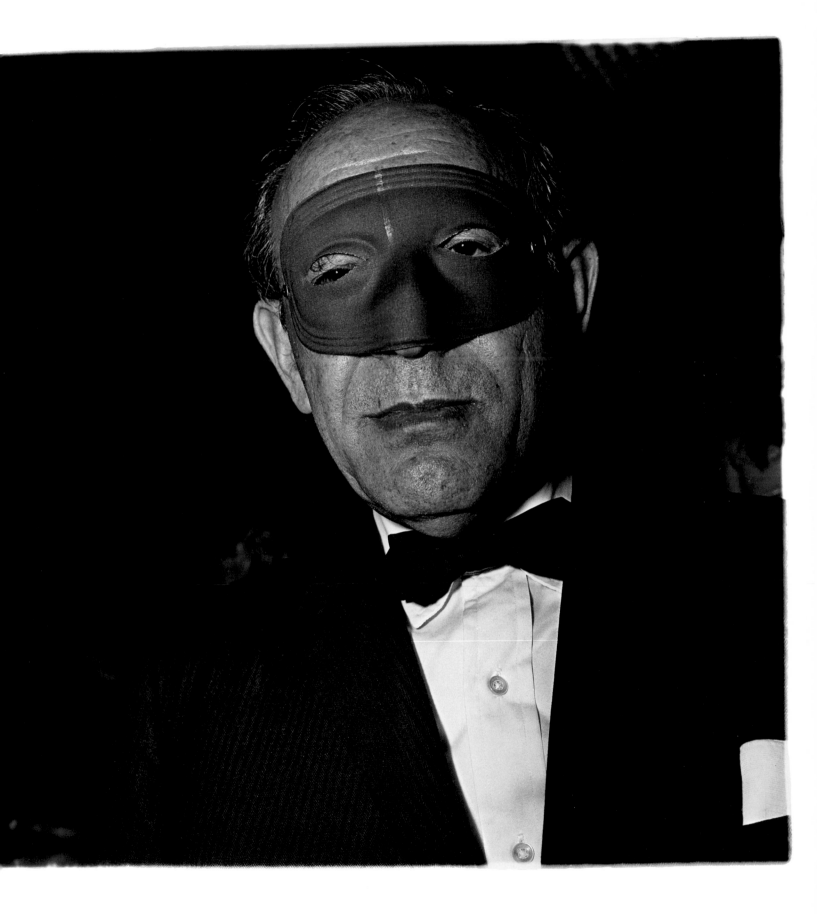

Nudist lady with swan sunglasses, Pa. 1965

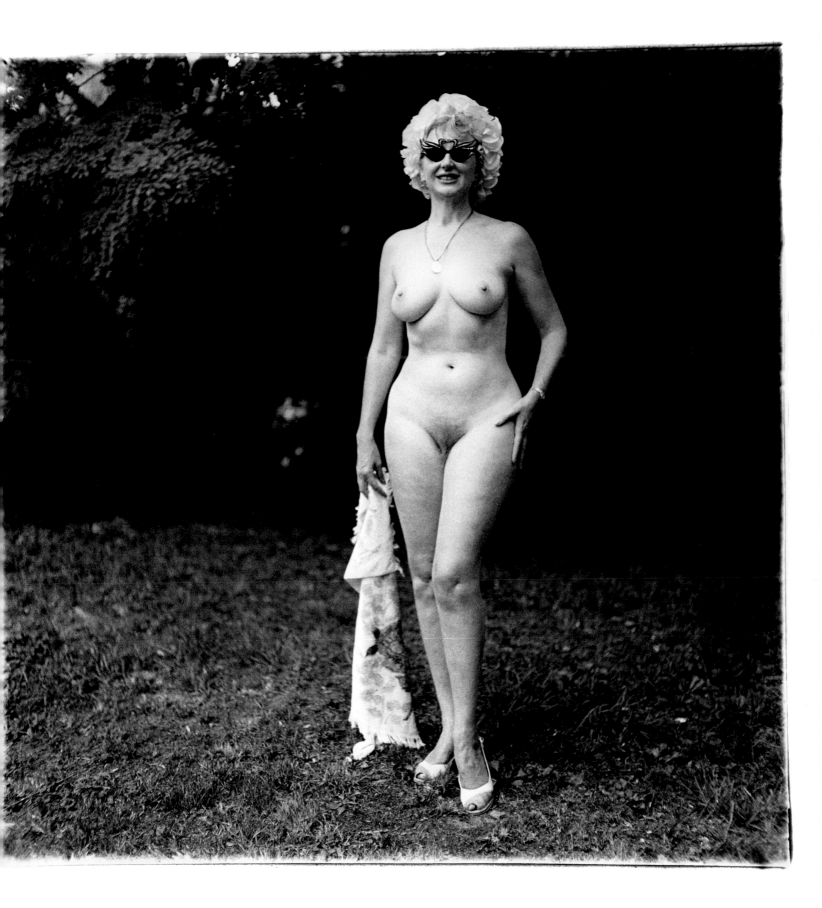

A woman with pearl necklace and earrings, N.Y.C. 1967

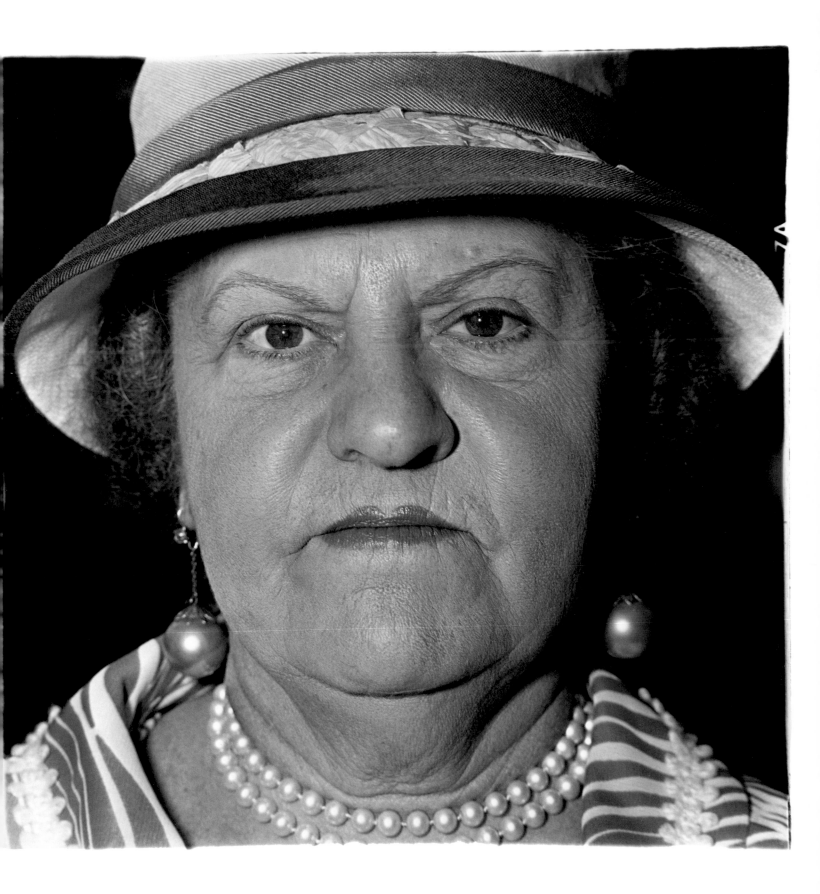

Man at a parade on Fifth Avenue, N.Y.C. 1969

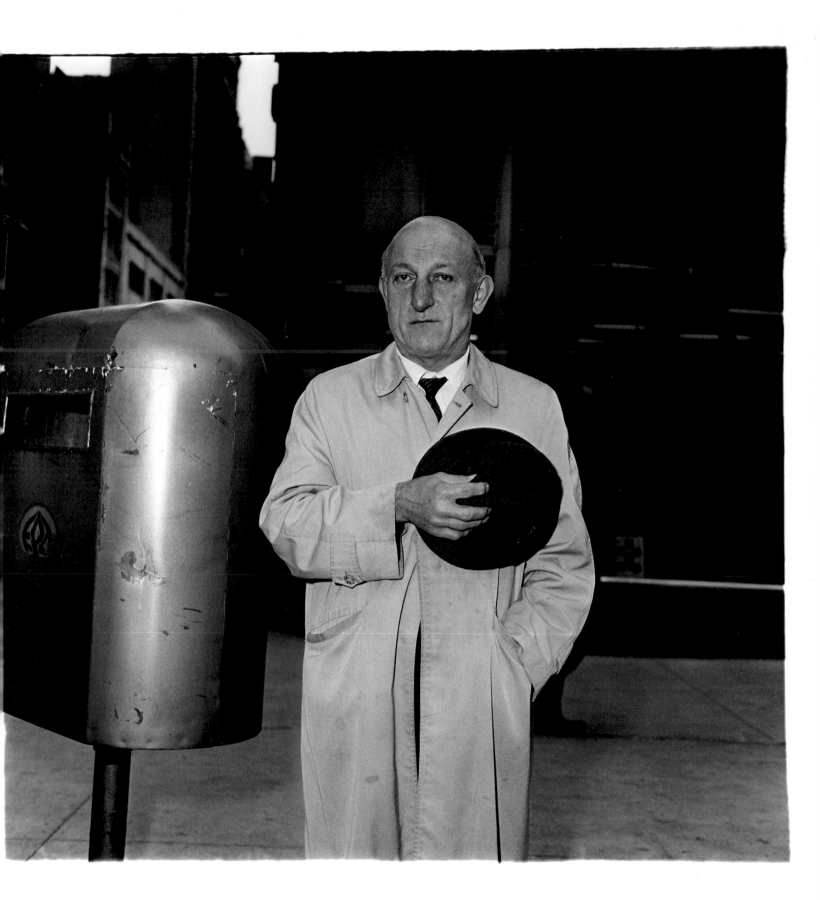

A young man and his pregnant wife in Washington Square Park, N.Y.C. 1965

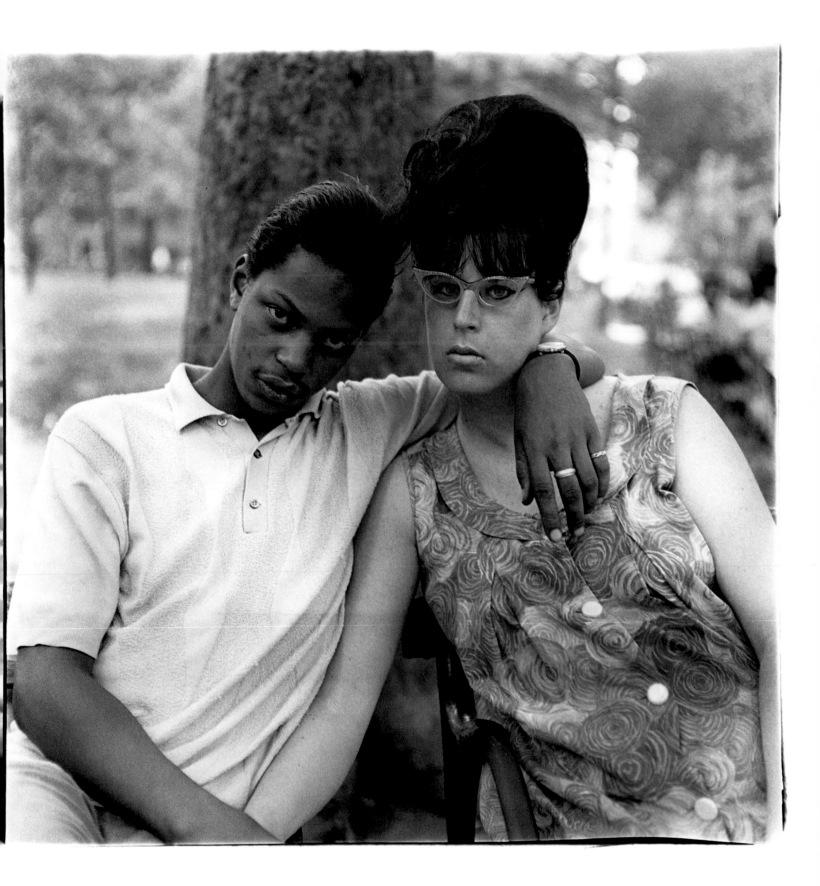

Hermaphrodite and a dog in a carnival trailer, Md. 1970

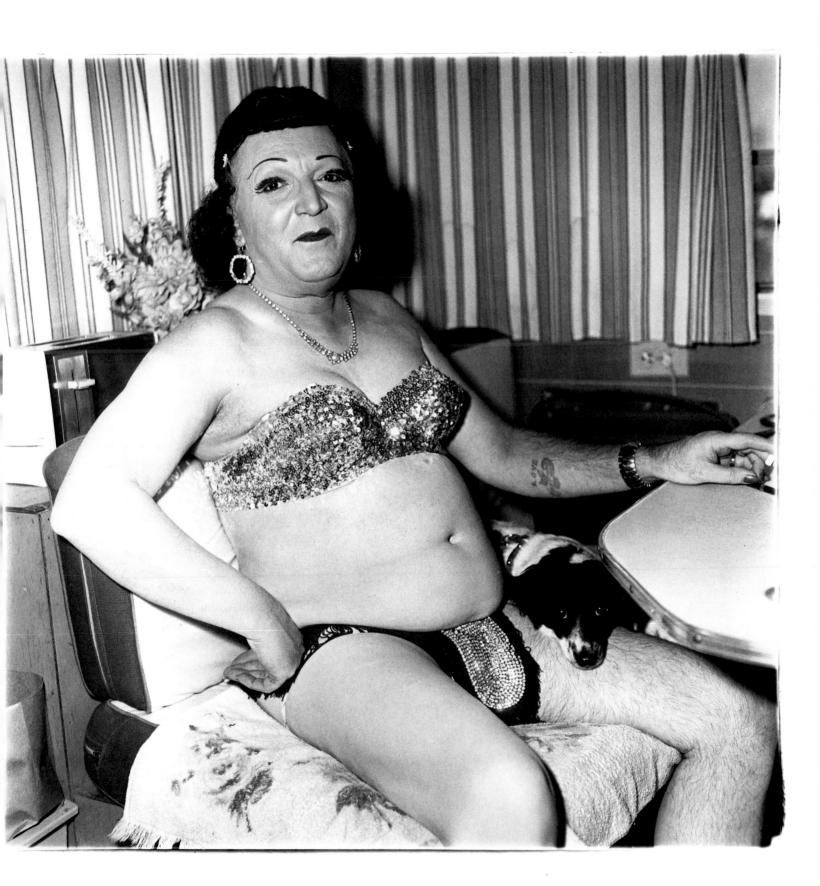

Woman on a park bench on a sunny day, N.Y.C. 1969

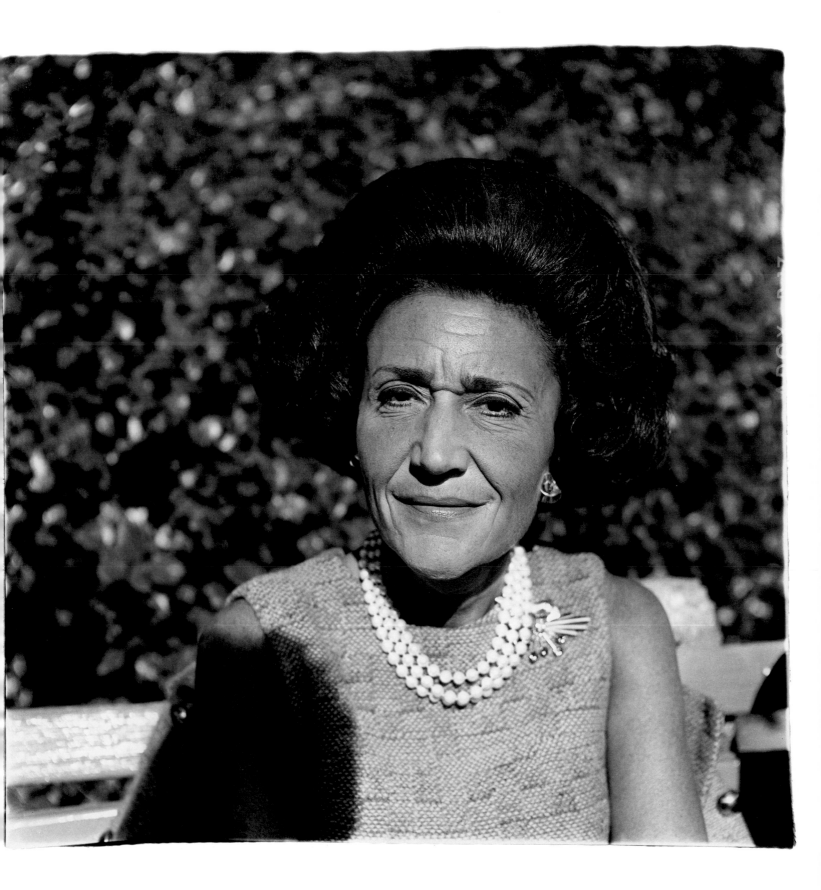

Topless dancer in her dressing room, San Francisco, Cal. 1968

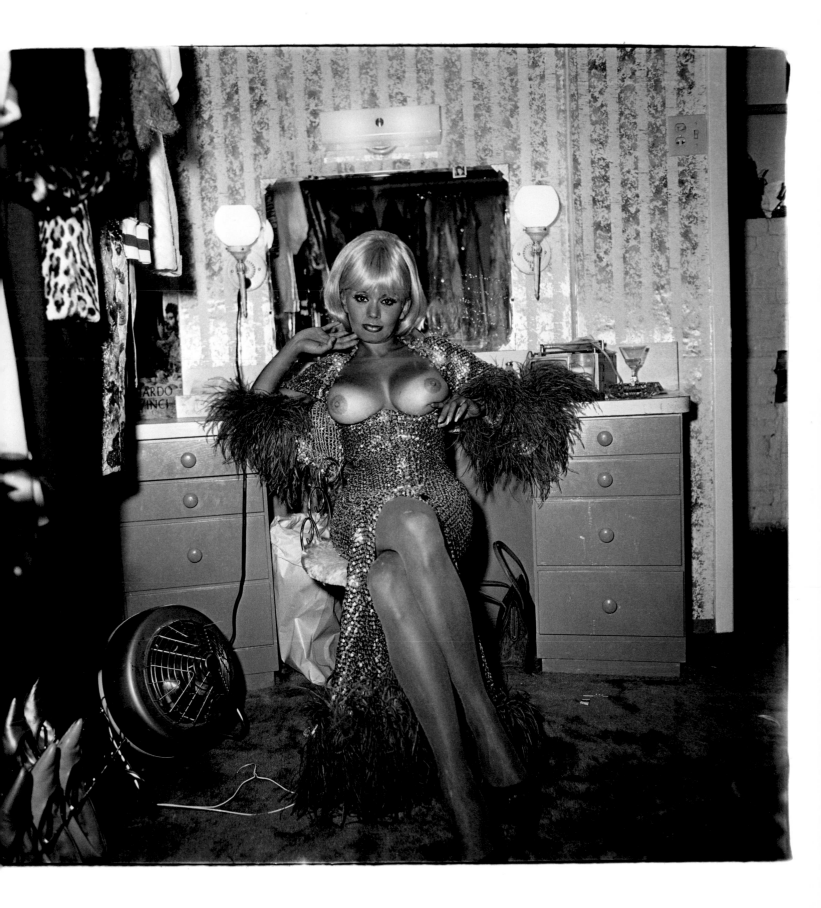

Patriotic young man with a flag, N.Y.C. 1967

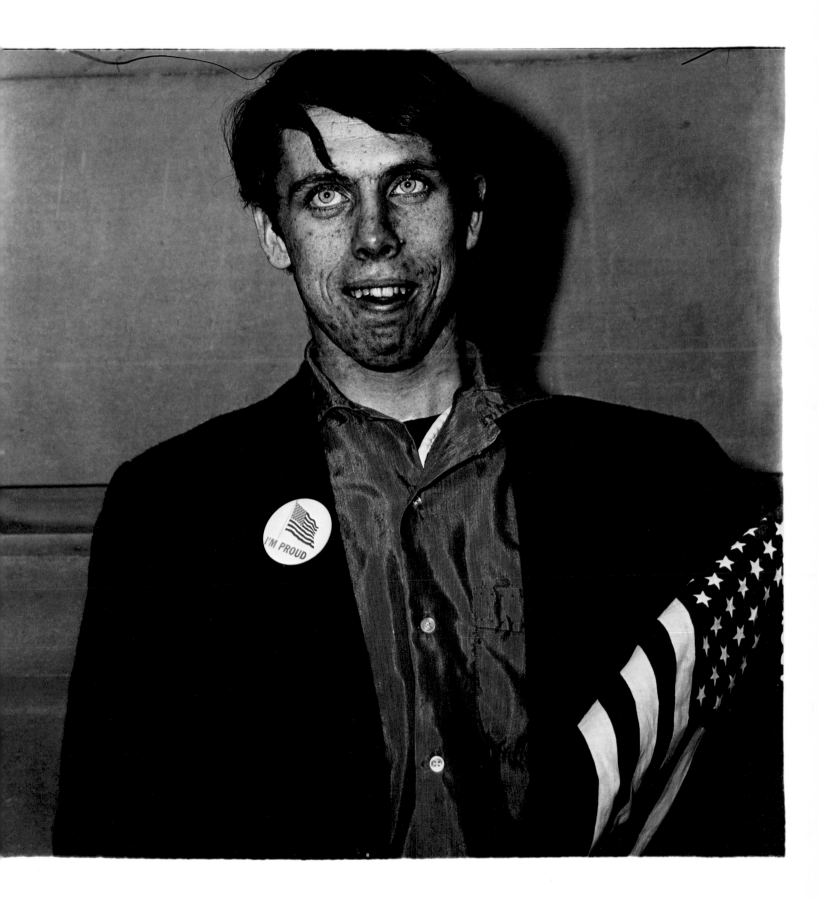

Masked woman in a wheelchair, Pa. 1970

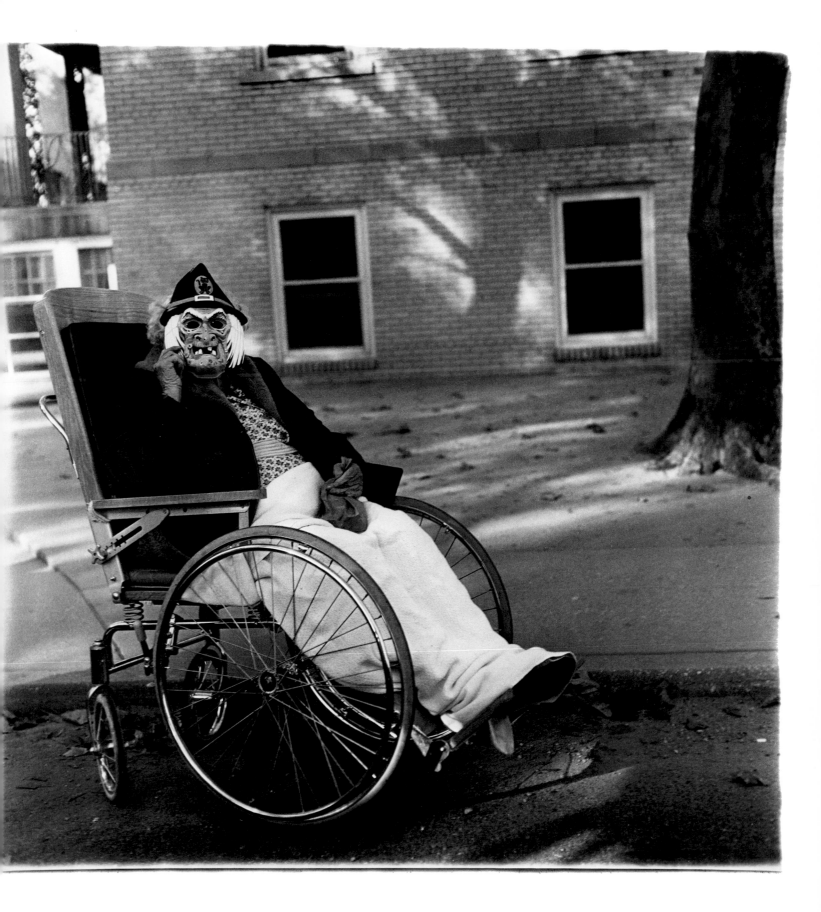

Teenage couple on Hudson Street, N.Y.C. 1963

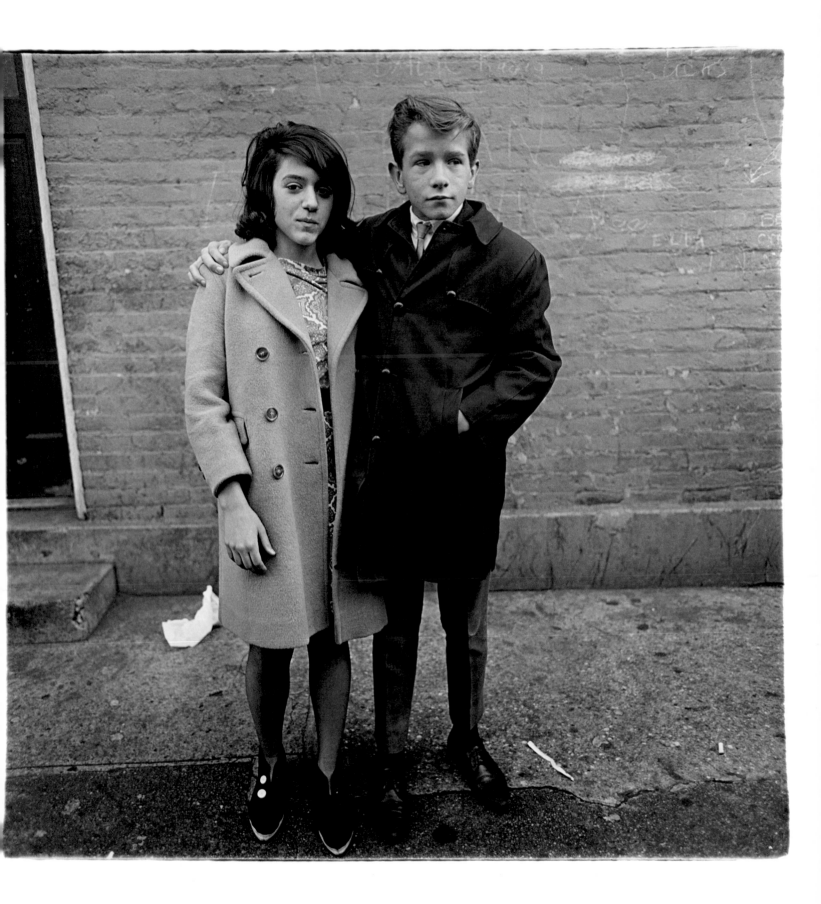

Girl sitting on her bed with her shirt off, N.Y.C. 1968

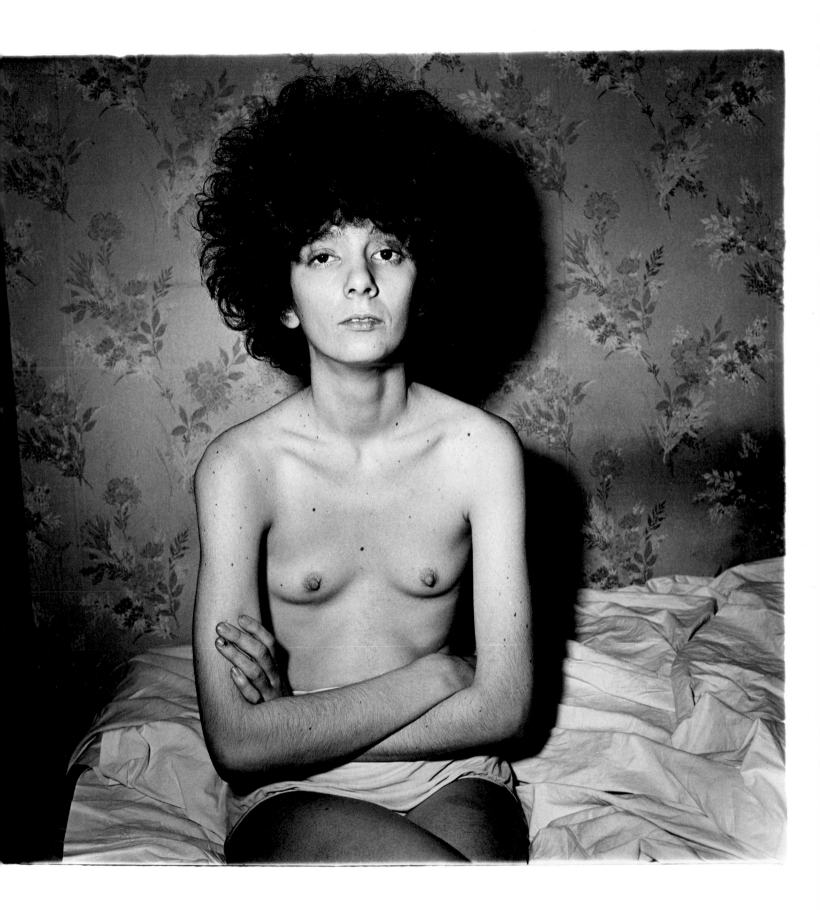

The King and Queen of a Senior Citizens Dance, N.Y.C. 1970

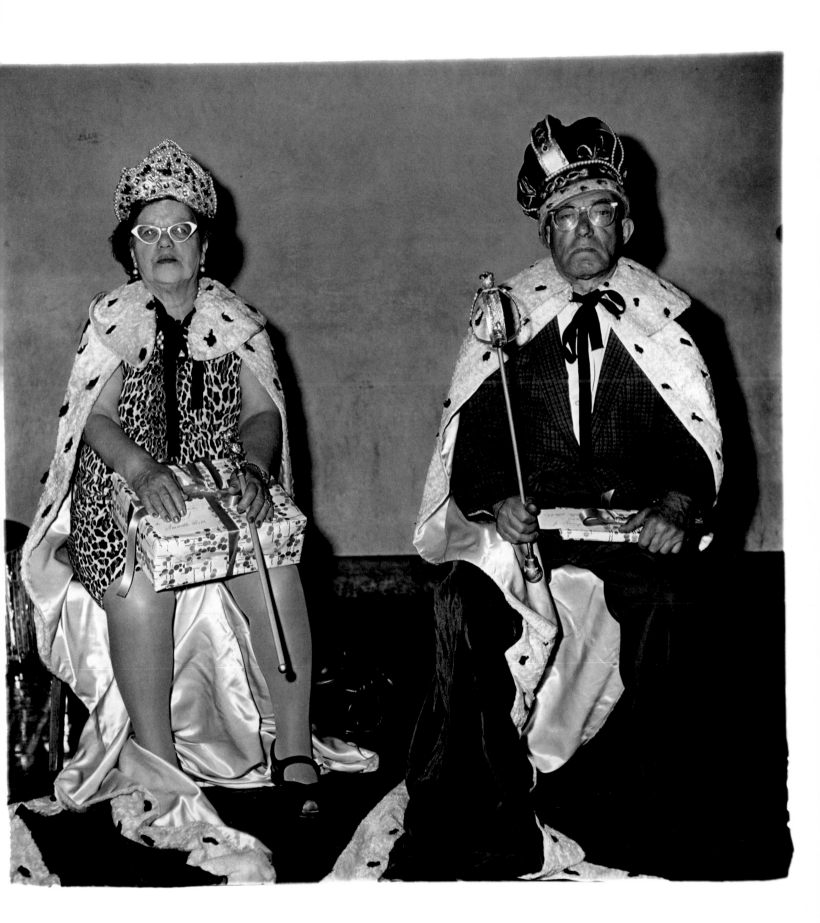

Blonde girl with shiny lipstick, N.Y.C. 1967

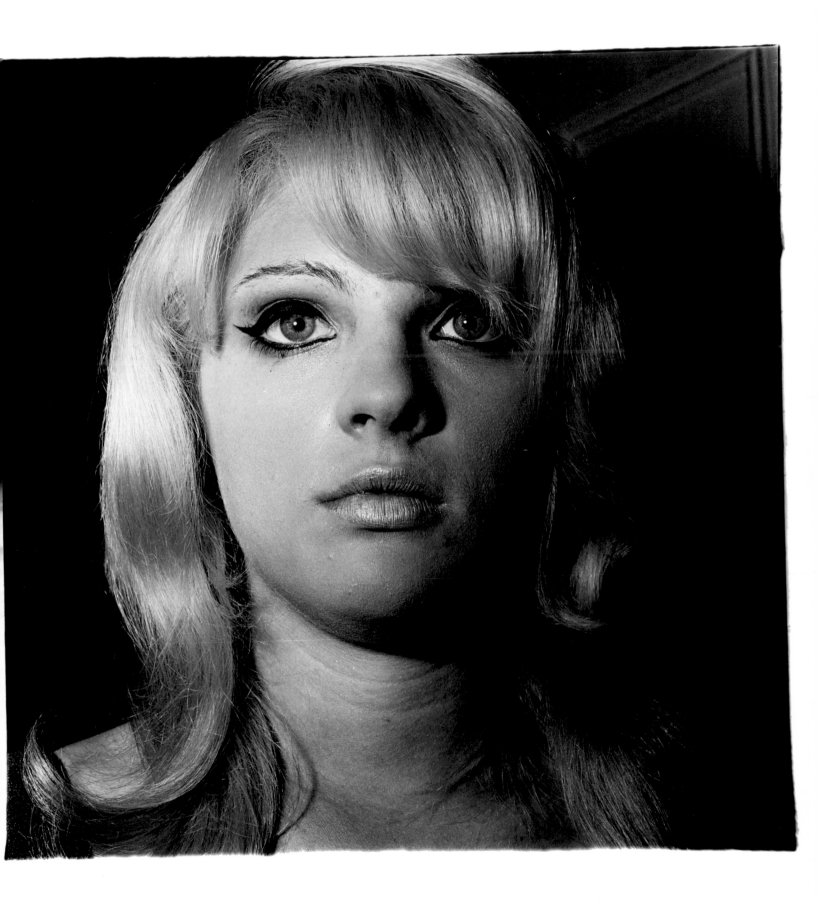

Muscle man contestant, N.Y.C. 1968

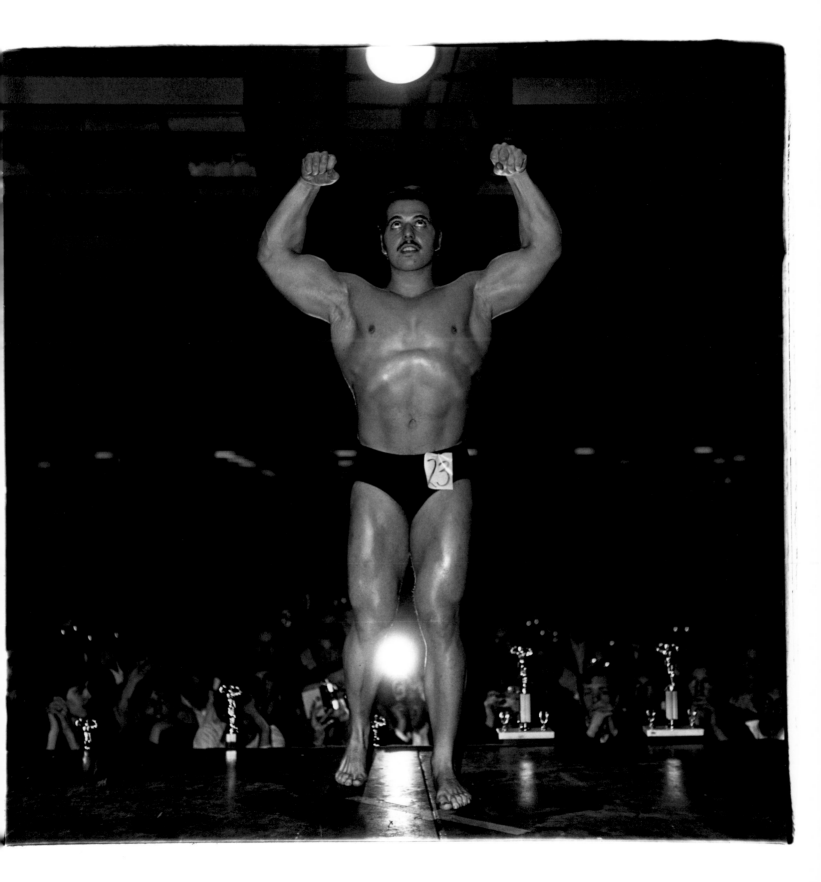

A woman in a bird mask, N.Y.C. 1967

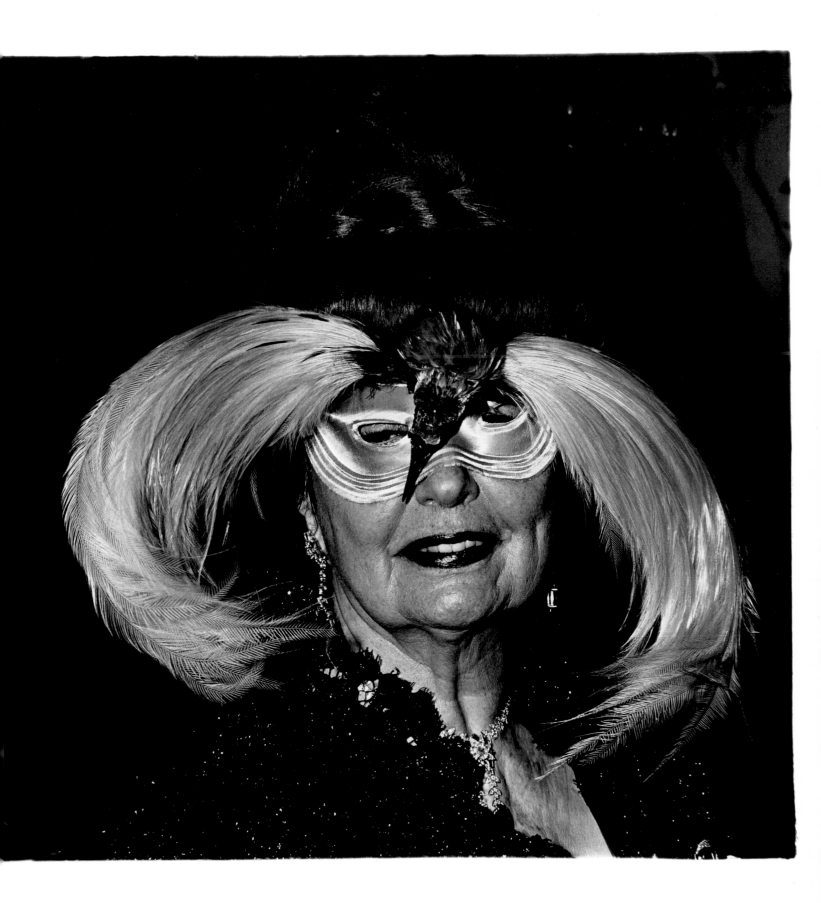

Young couple on a bench in Washington Square Park, N.Y.C. 1965

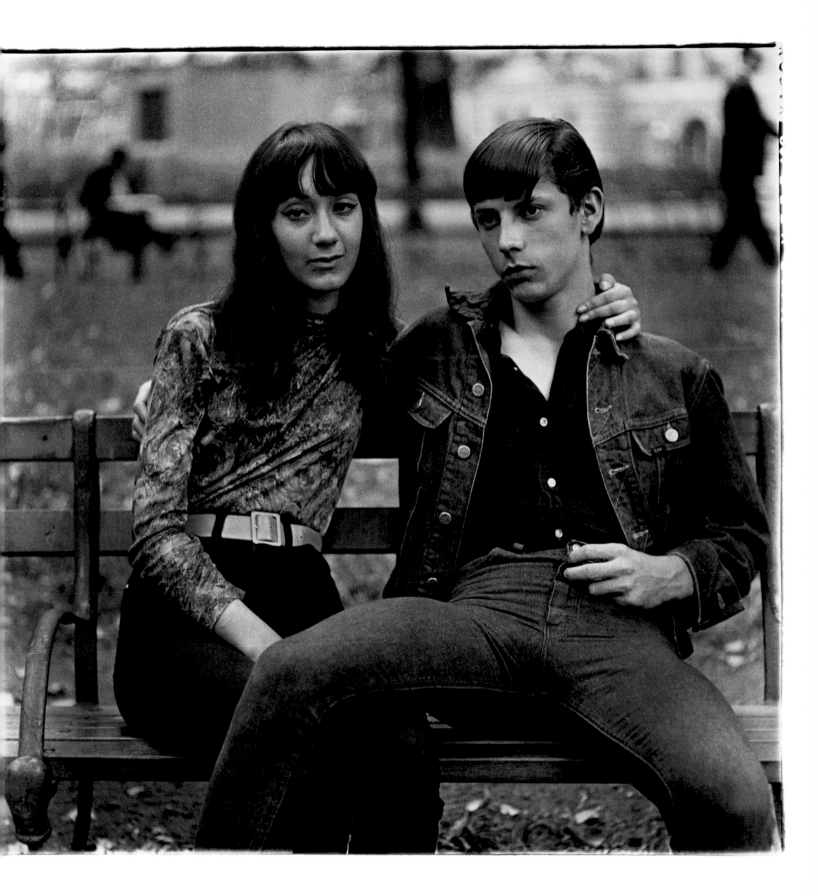

Child with a toy hand grenade in Central Park, N.Y.C. 1962

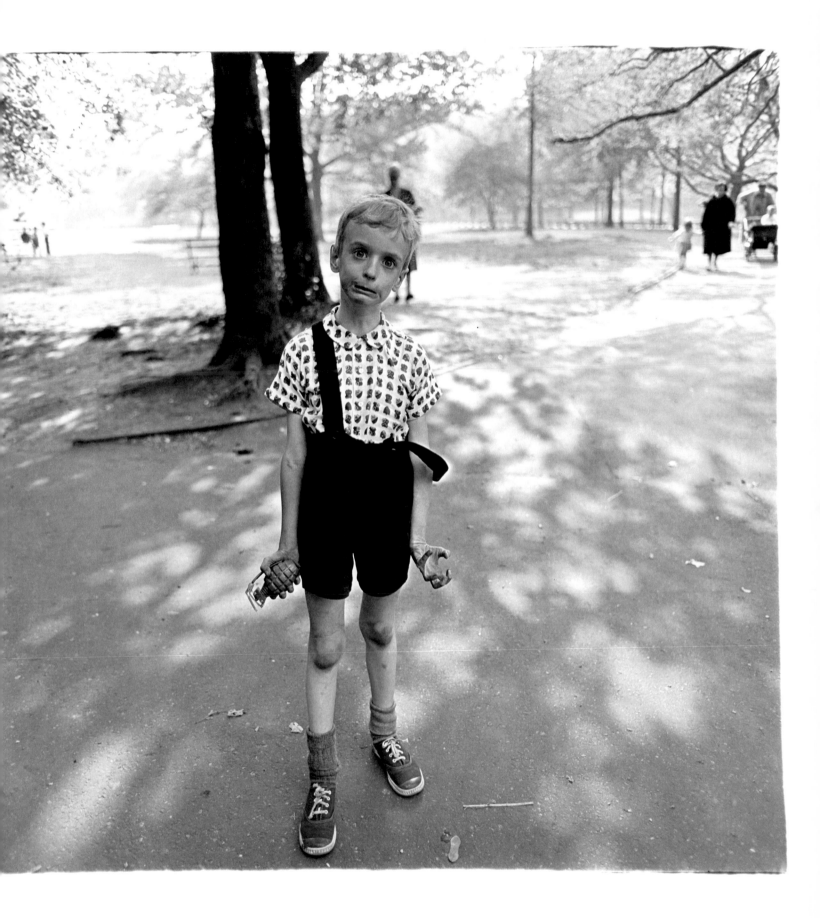

Two girls in matching bathing suits, Coney Island, N.Y. 1967

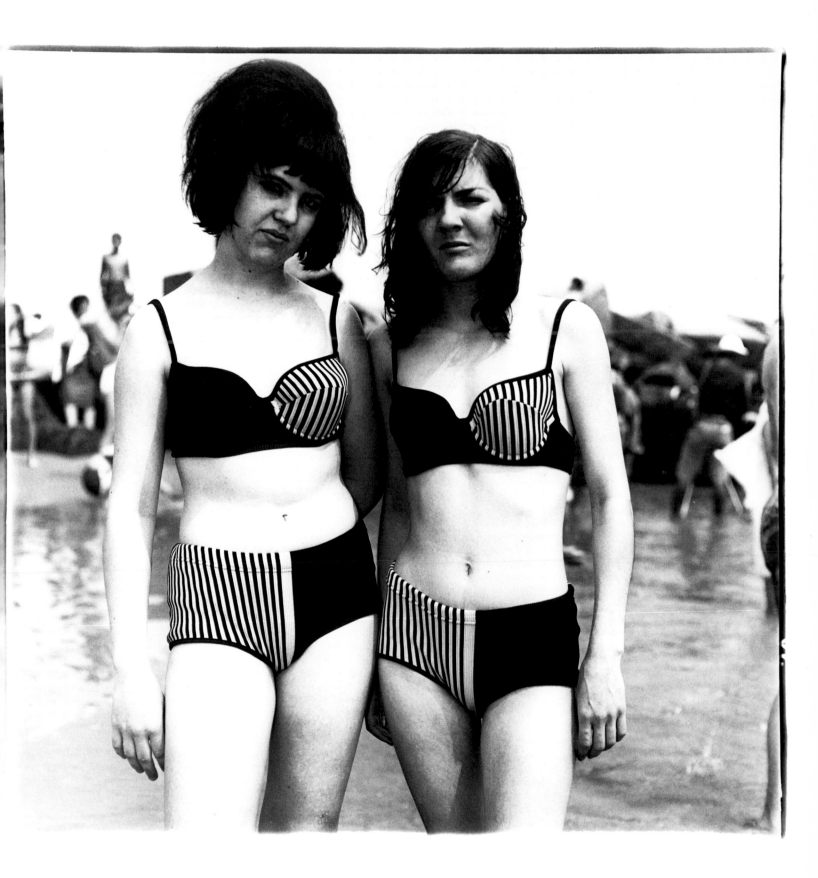

Girl in her circus costume, Md. 1970

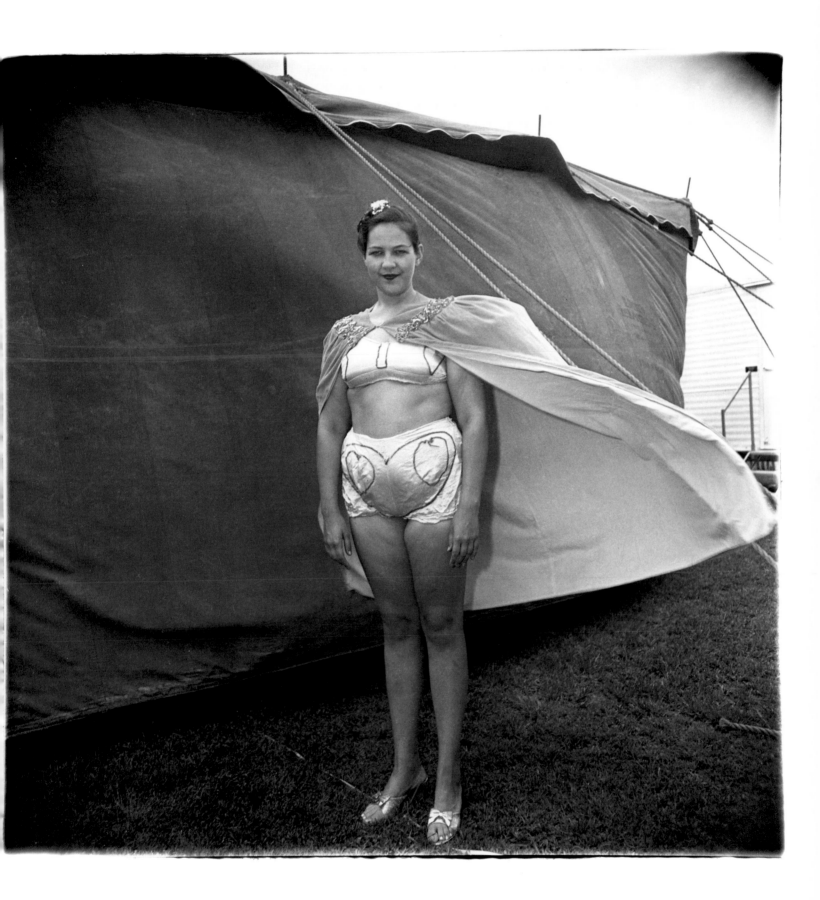

Mother holding her child, N.J. 1967

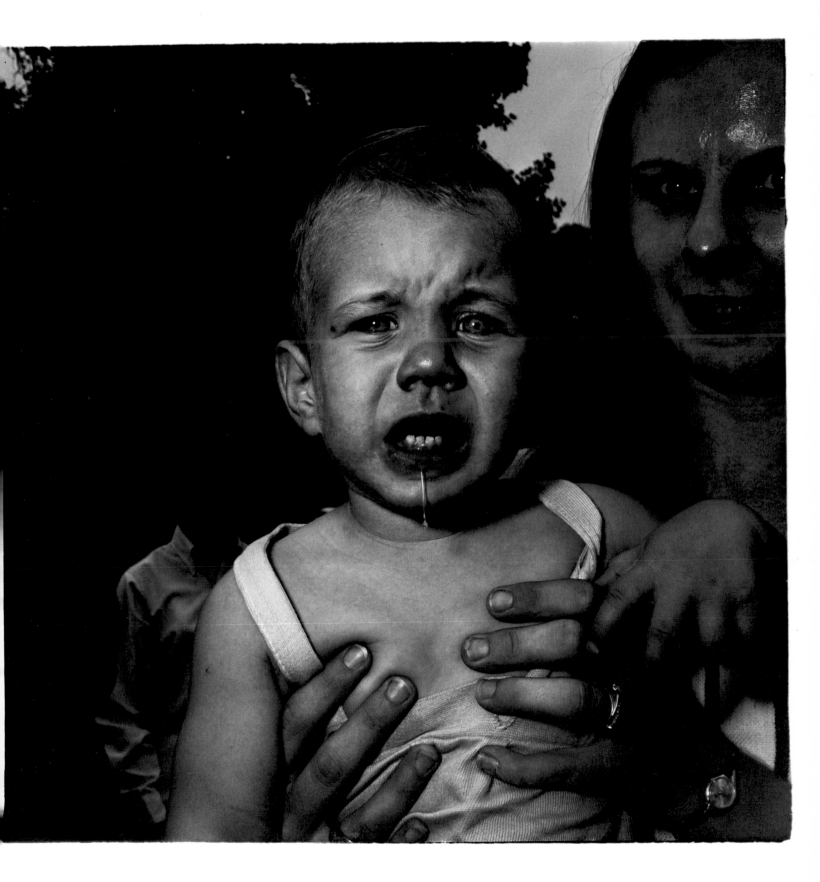

Seated man in a bra and stockings, N.Y.C. 1967

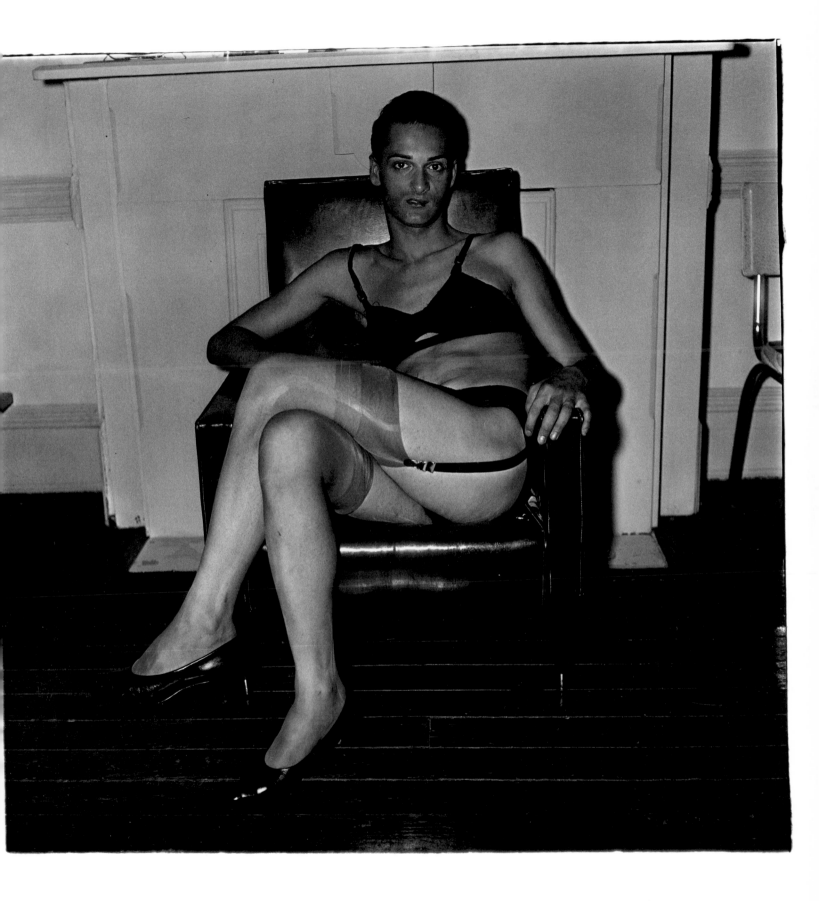

Man in an Indian headress, N.Y.C. 1969

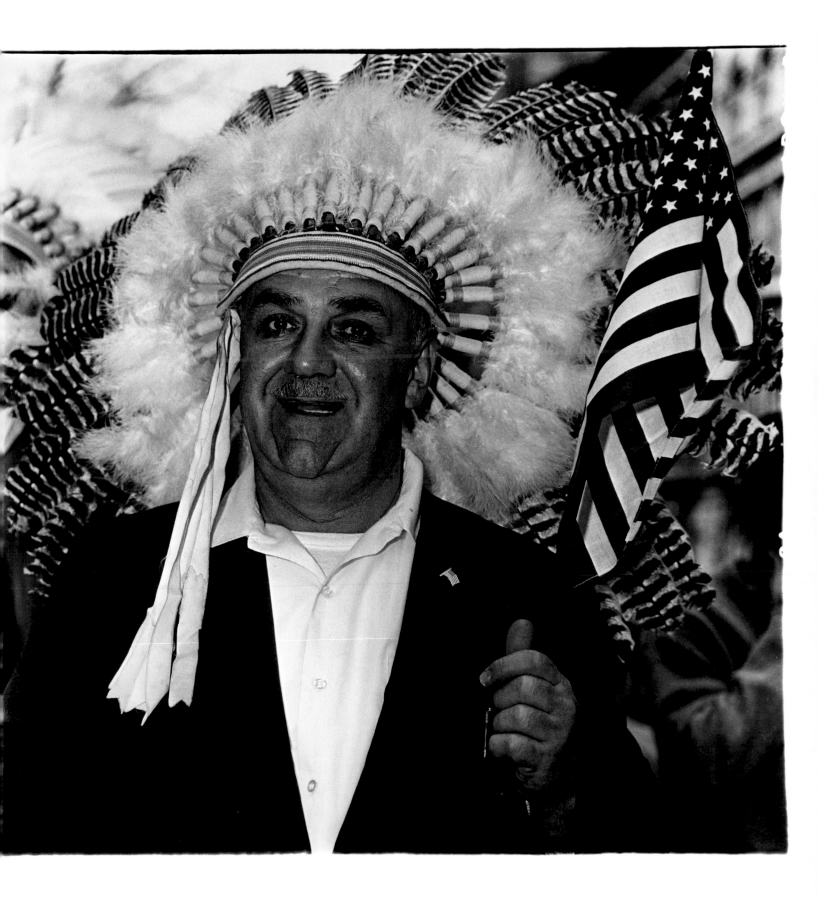

A Puerto Rican housewife, N.Y.C. 1963

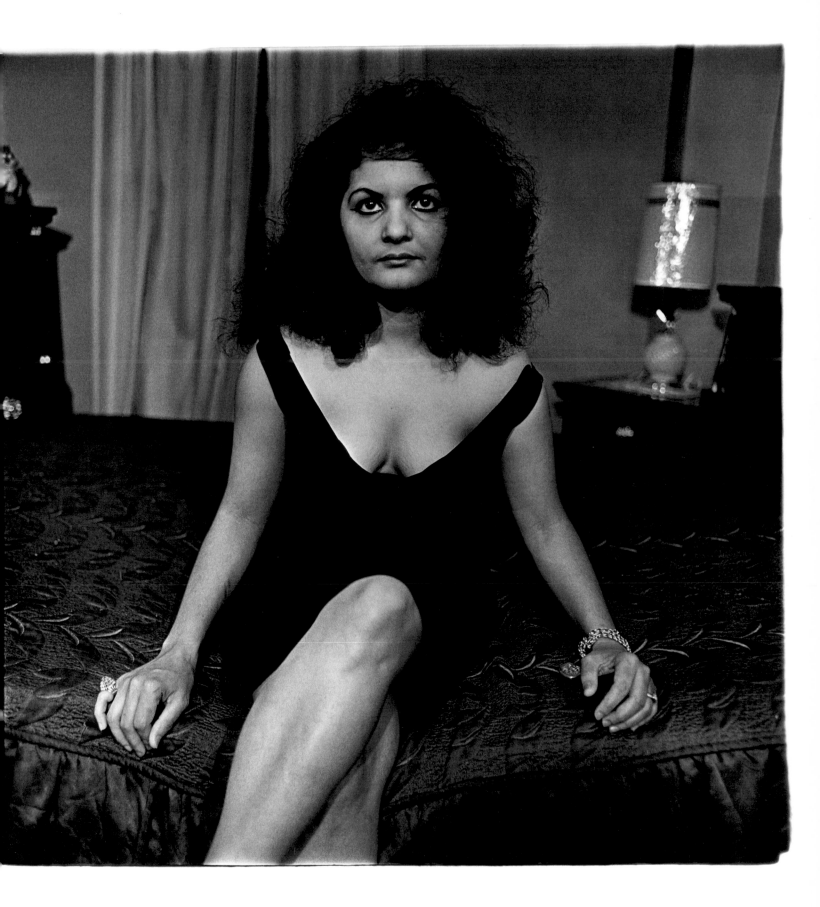

Two boys smoking in Central Park, N.Y.C. 1963

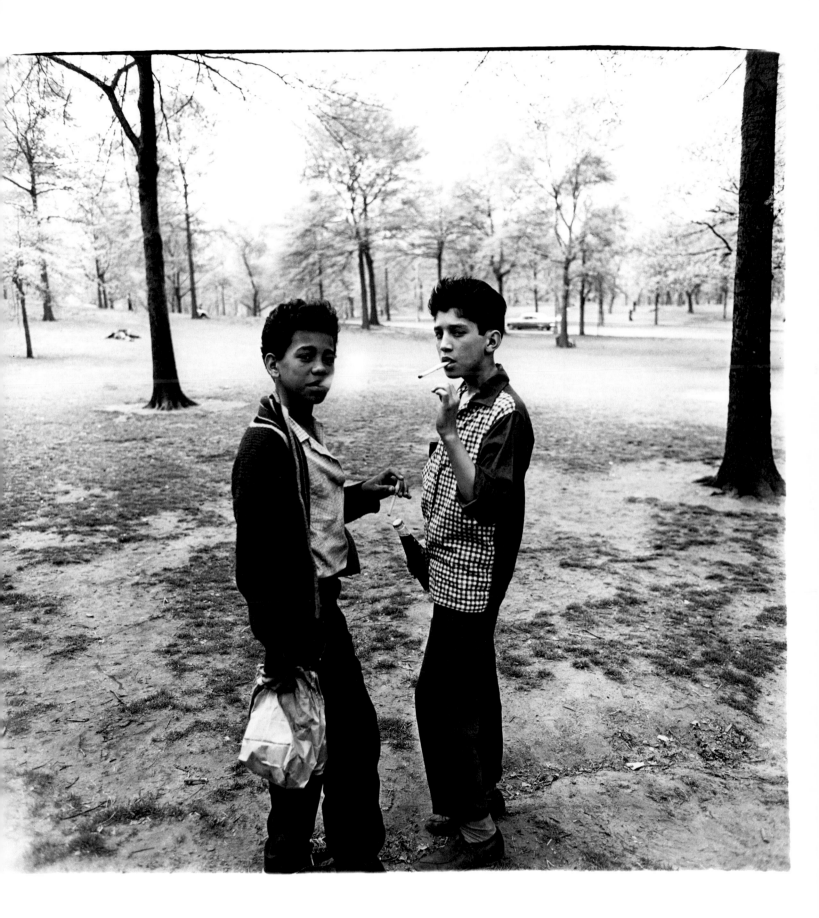

Woman with a veil on Fifth Avenue, N.Y.C. 1968

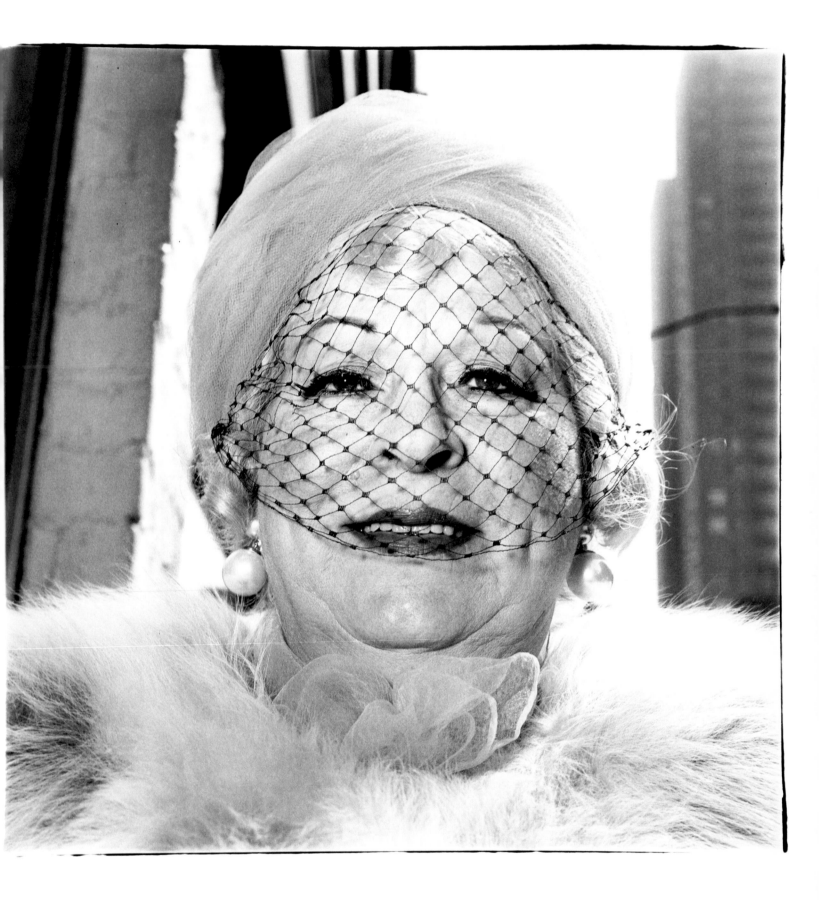

A naked man being a woman, N.Y.C. 1968

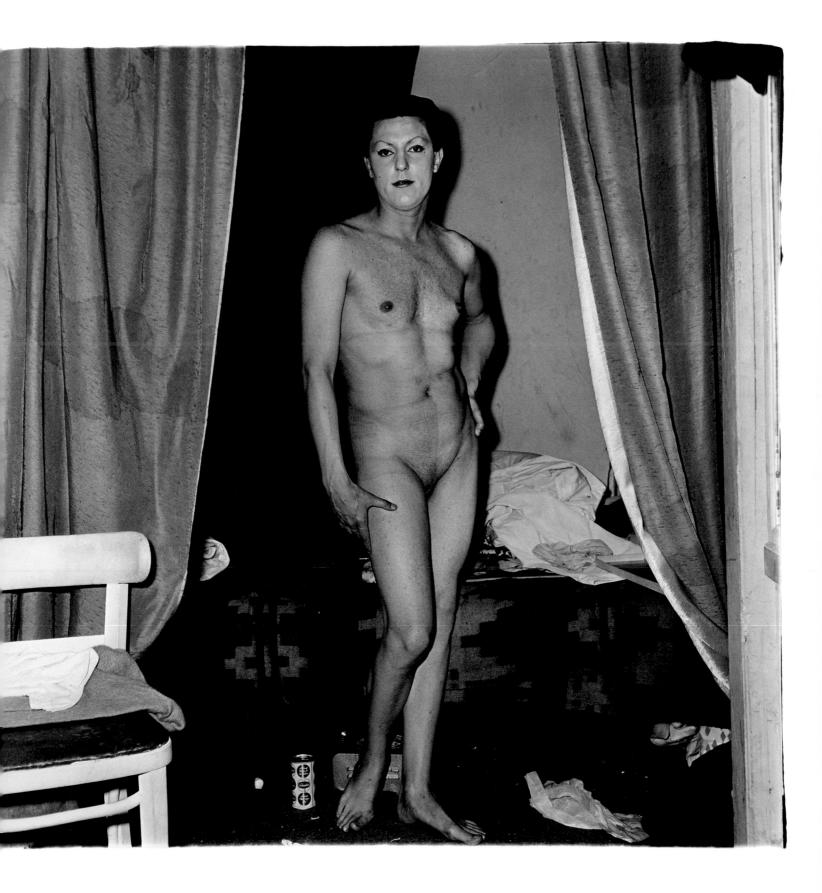

Man dancing with a large woman, N.Y.C. 1967

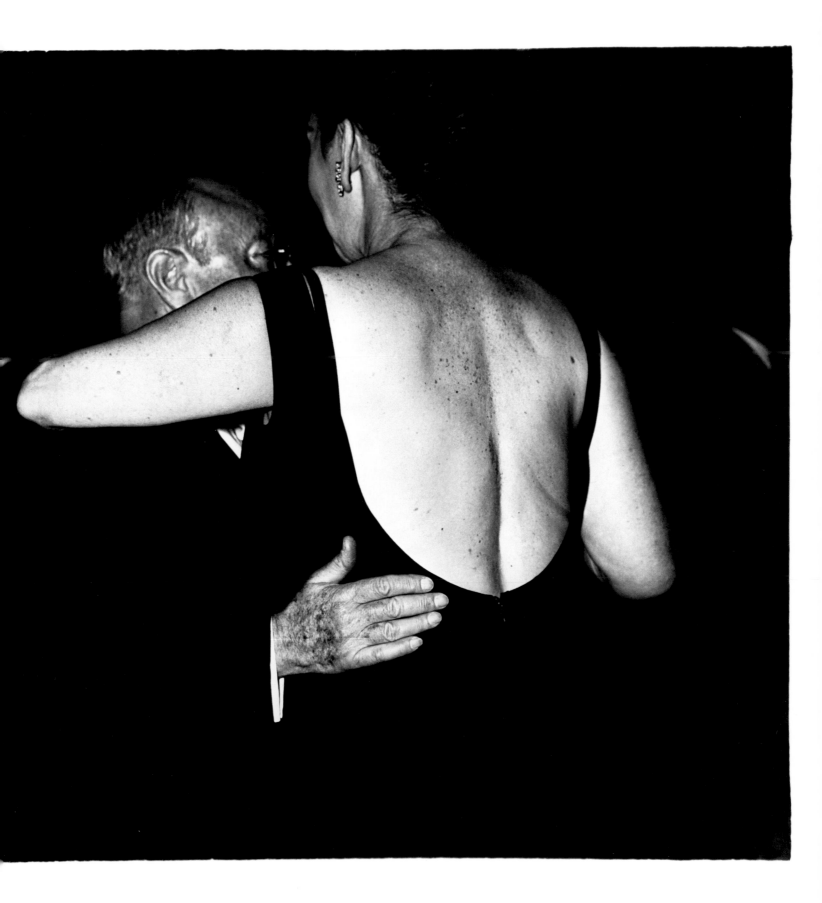

Lady bartender at home with a souvenir dog, New Orleans, 1964

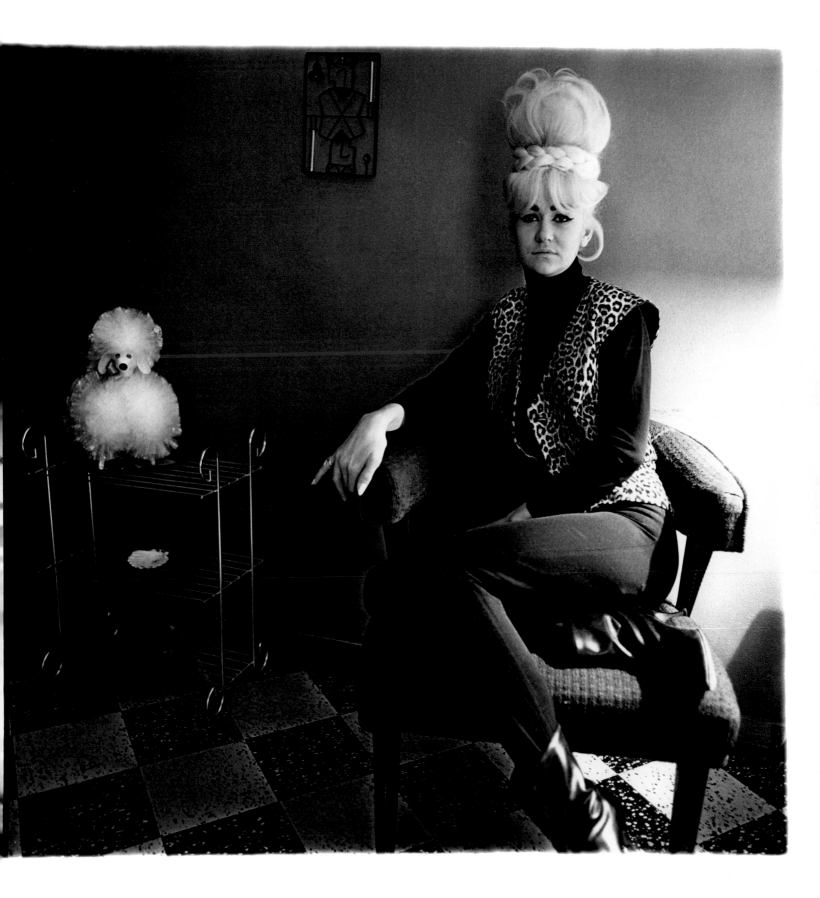

Transvestite at a drag ball, N.Y.C. 1970

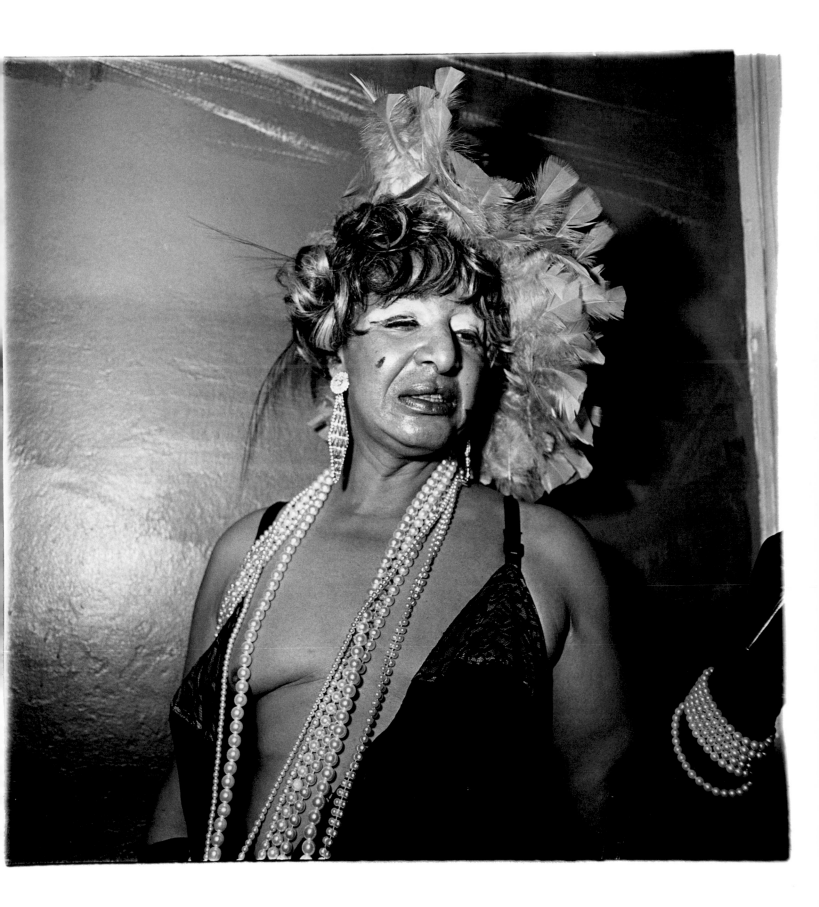

A woman with her baby monkey, N.J. 1971

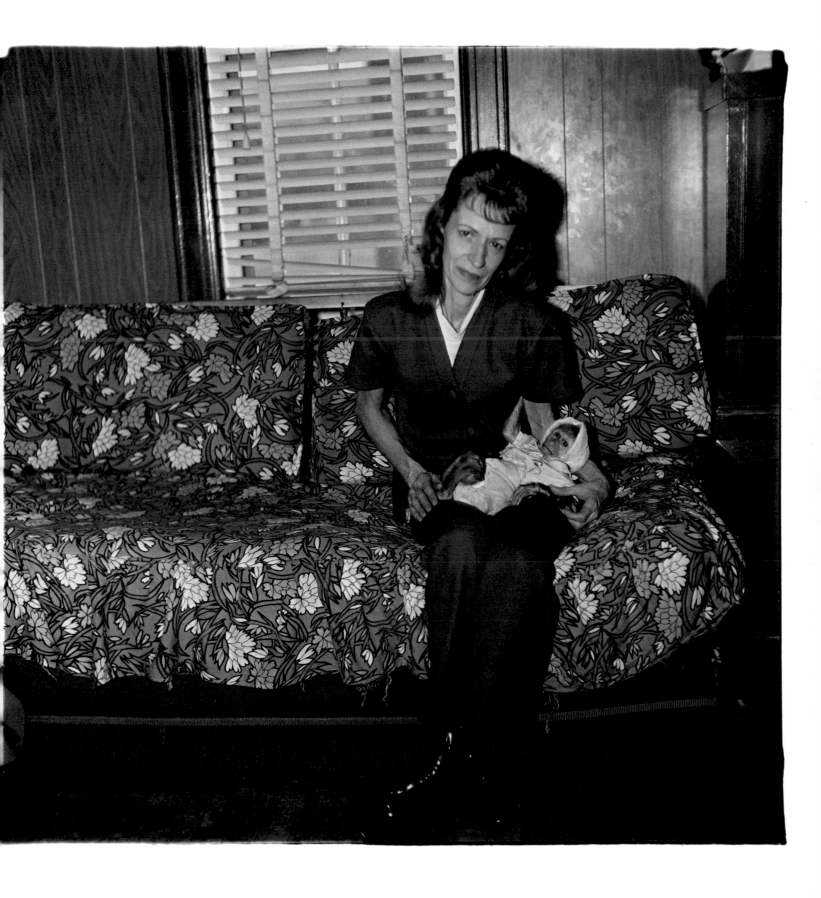

Woman with a fur collar on the street, N.Y.C. 1968

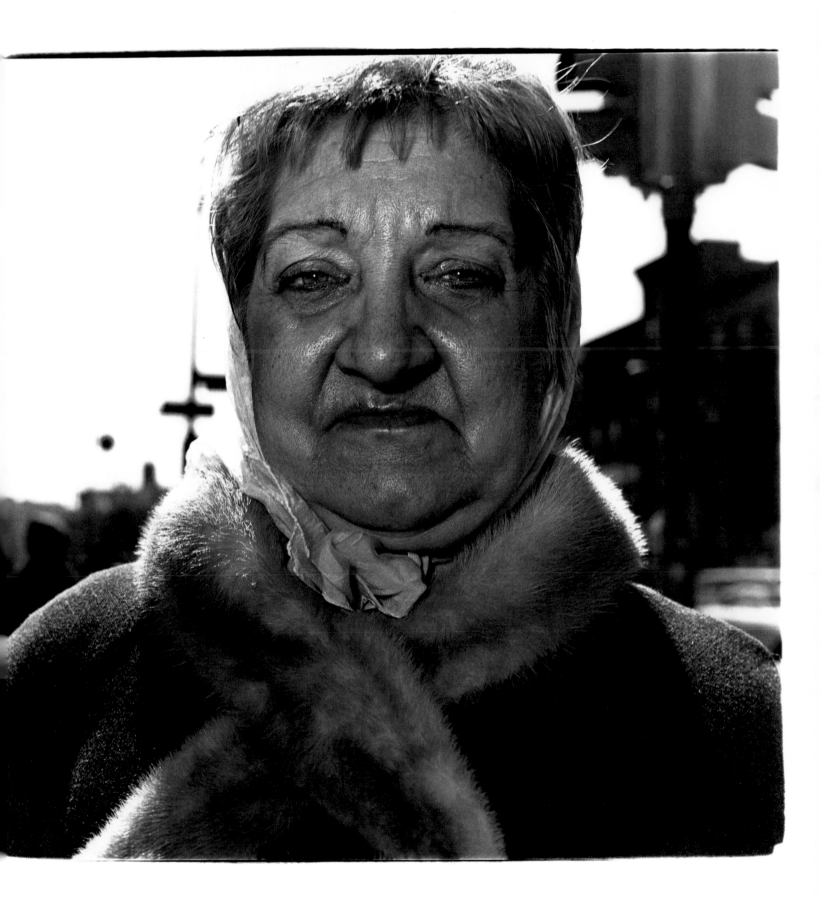

Man and a boy on a bench in Central Park, N.Y.C. 1962

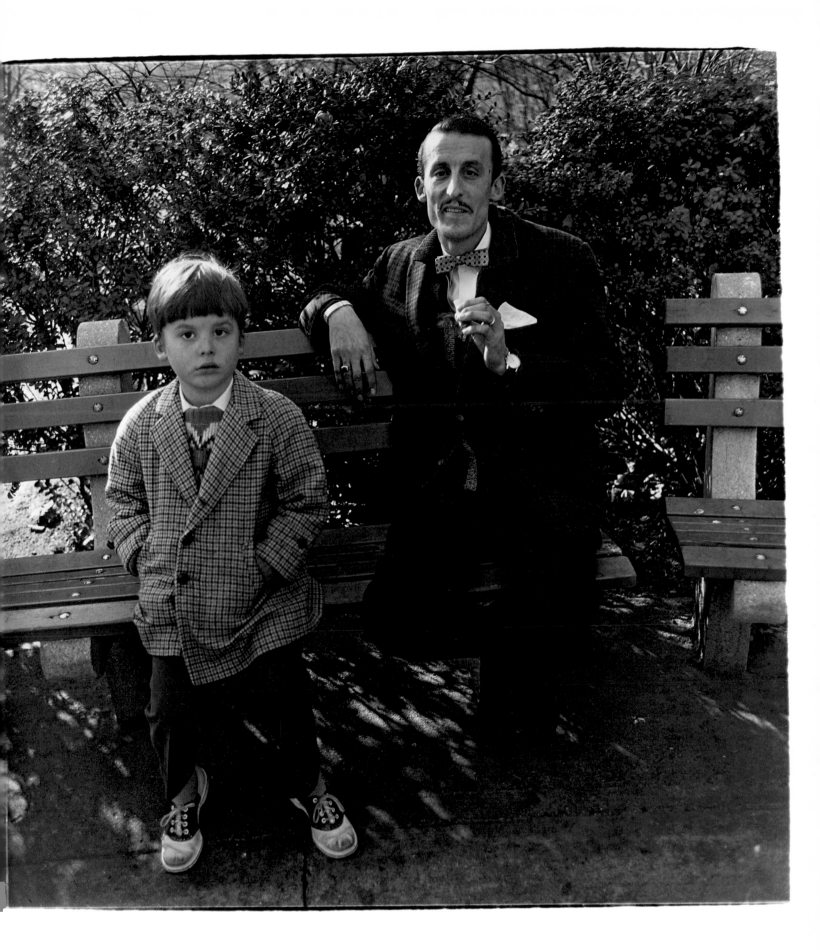

Woman in her negligee, N.Y.C. 1966

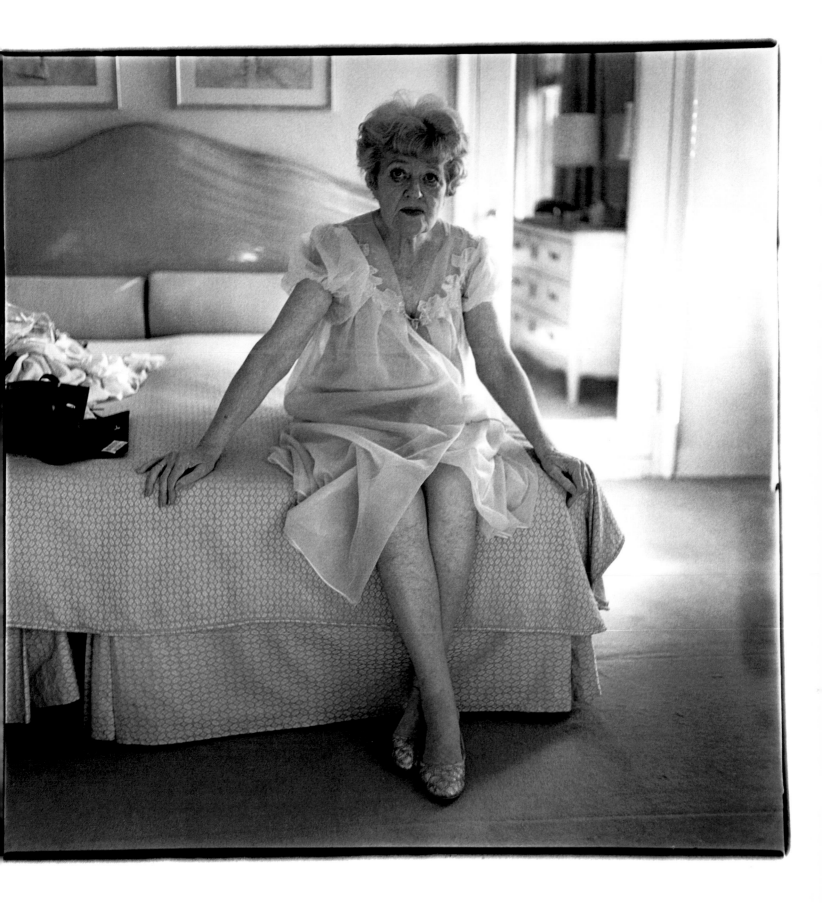

Tattooed man at a carnival, Md. 1970

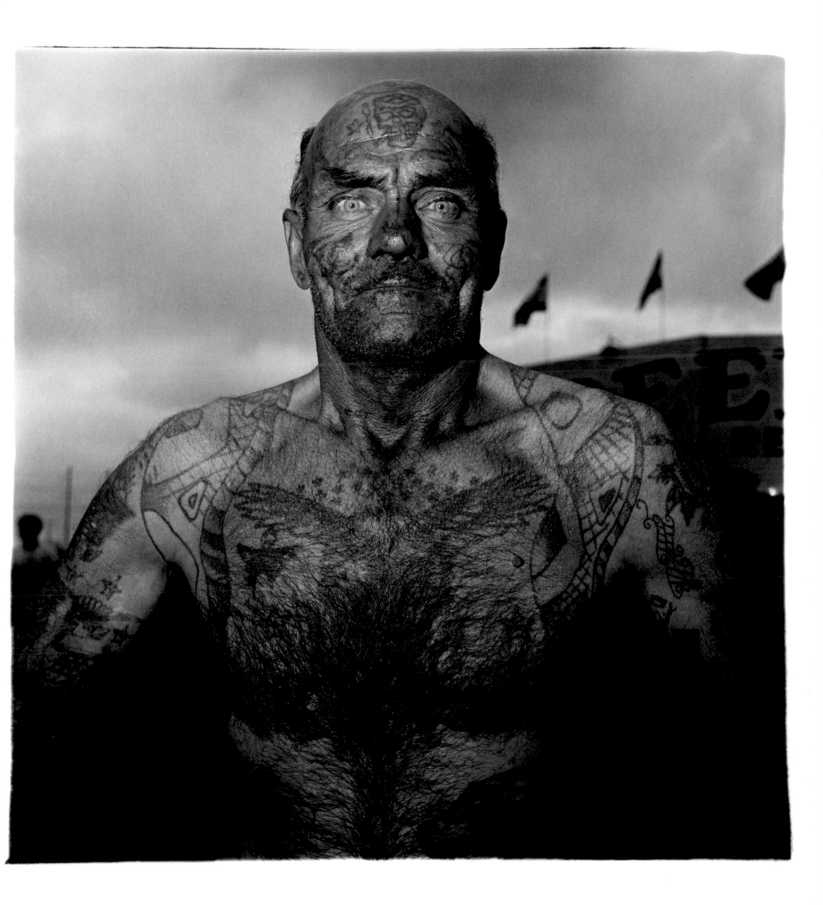

A widow in her bedroom, N.Y.C. 1963

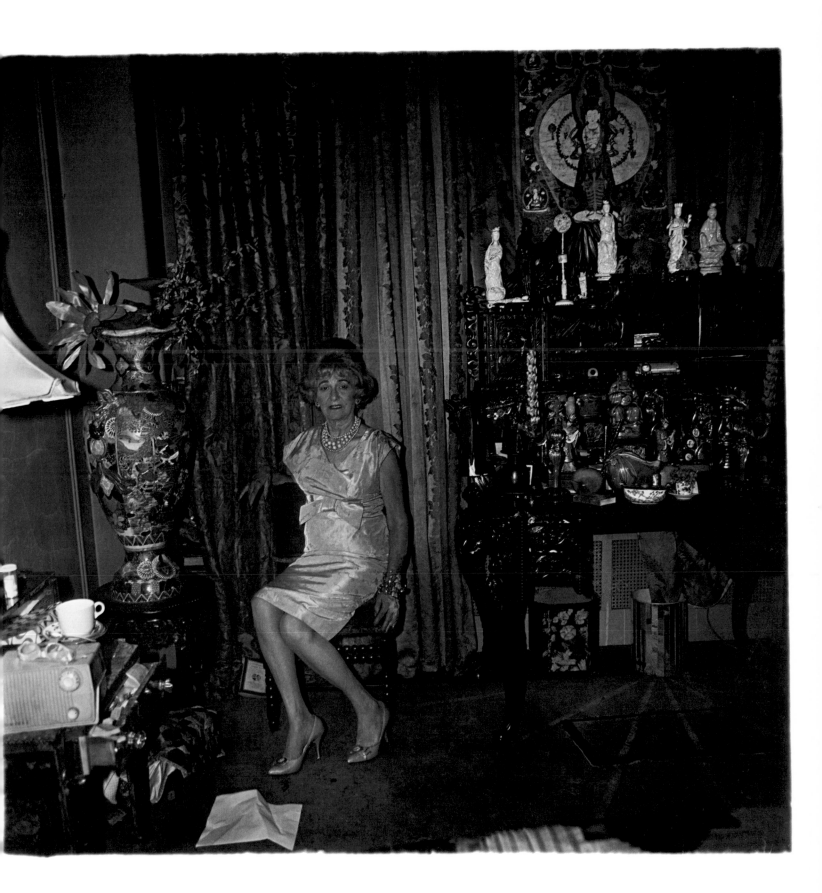

Girl in a shiny dress, N.Y.C. 1967

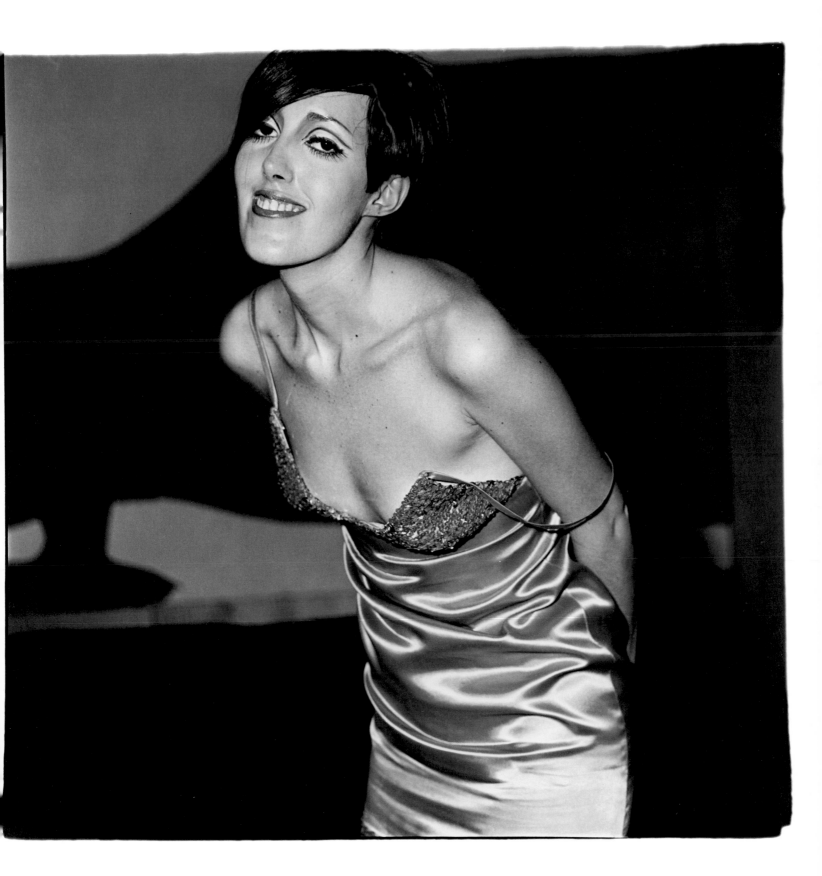

Two friends at home, N.Y.C. 1965

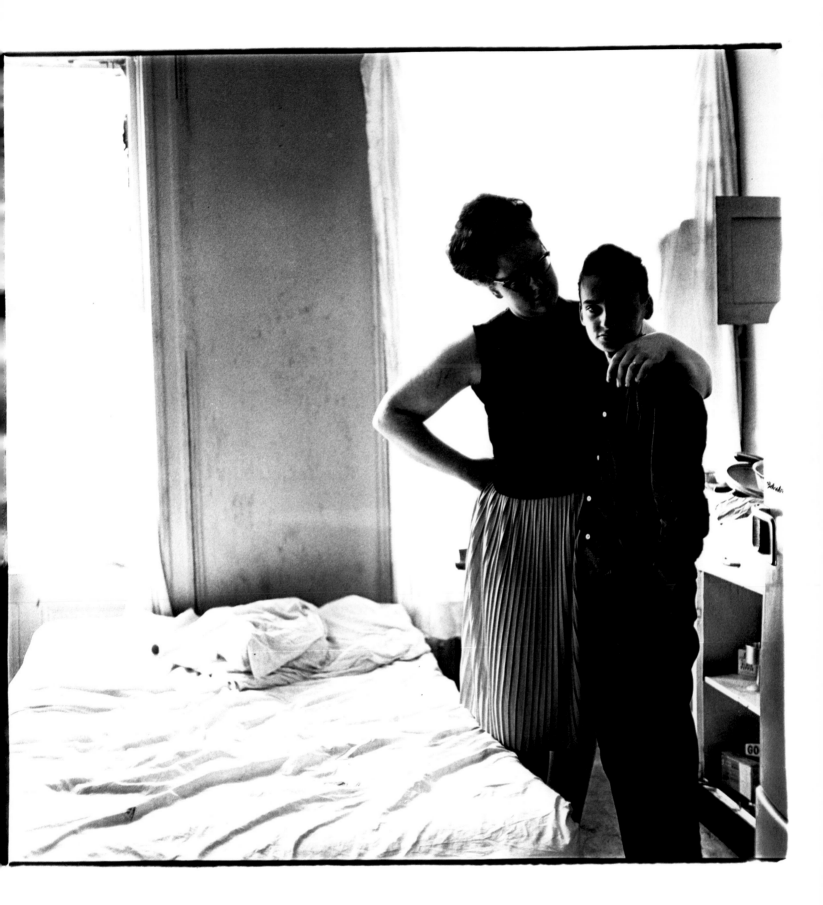

Transvestite with torn stocking, N.Y.C. 1966

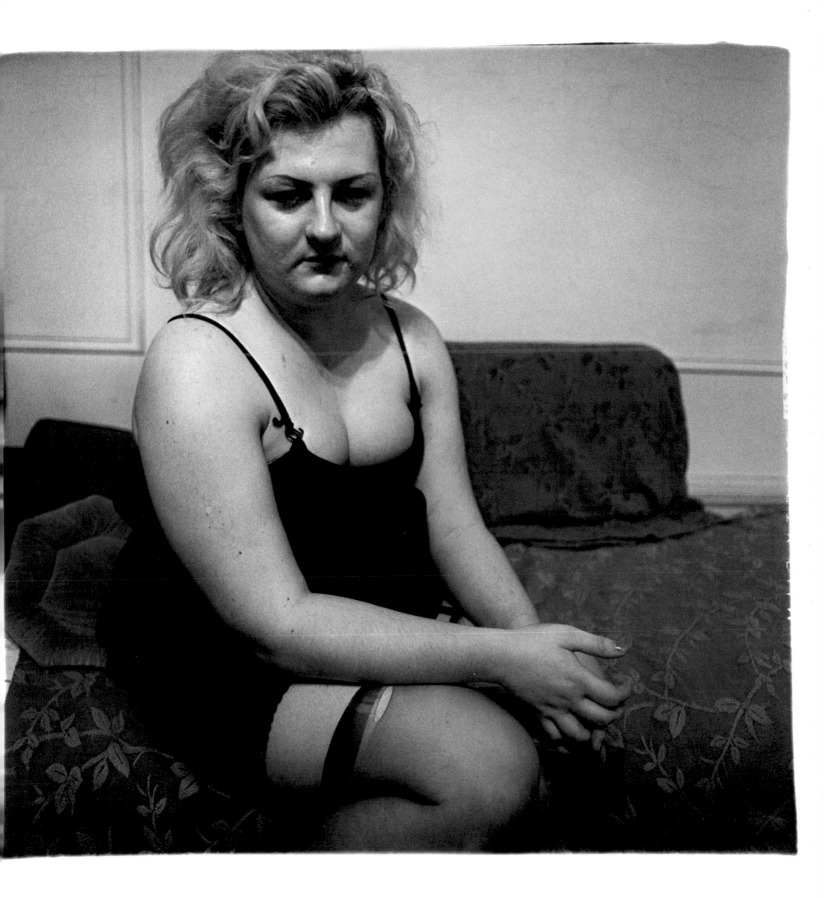

Albino sword swallower at a carnival, Md. 1970

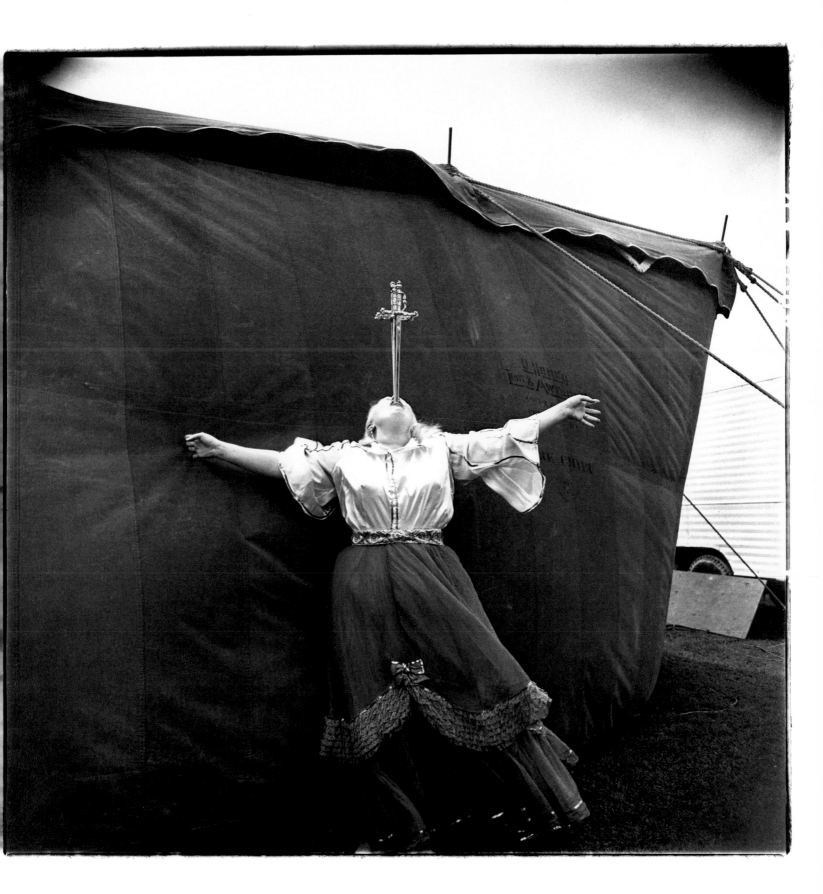

A house on a hill, Hollywood, Cal. 1963

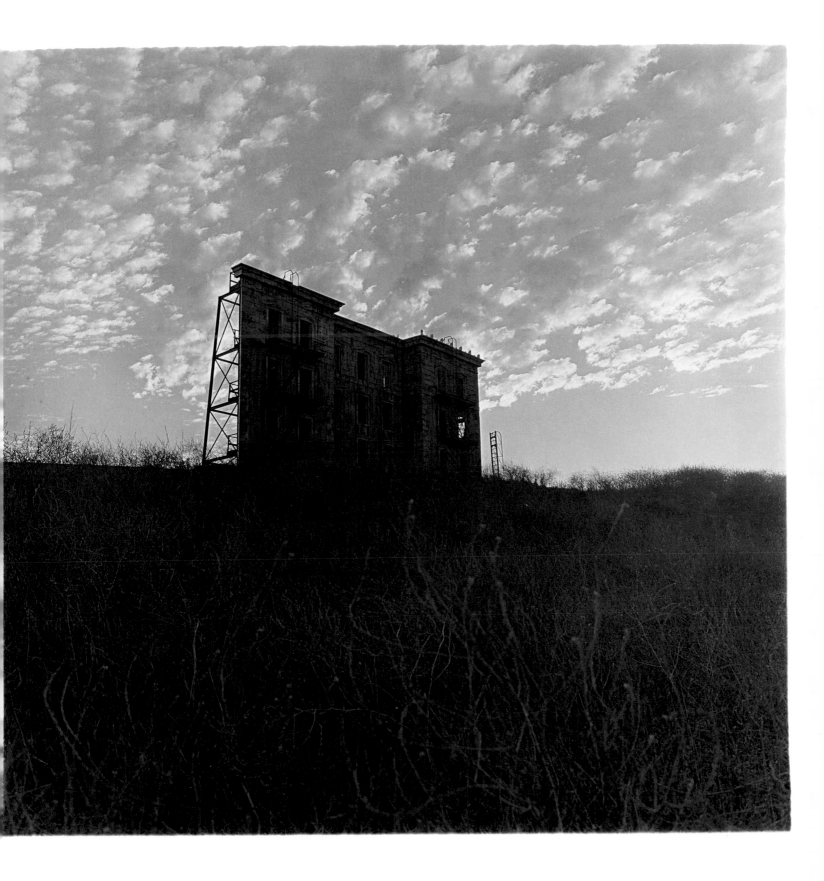

Untitled (1) 1970-71

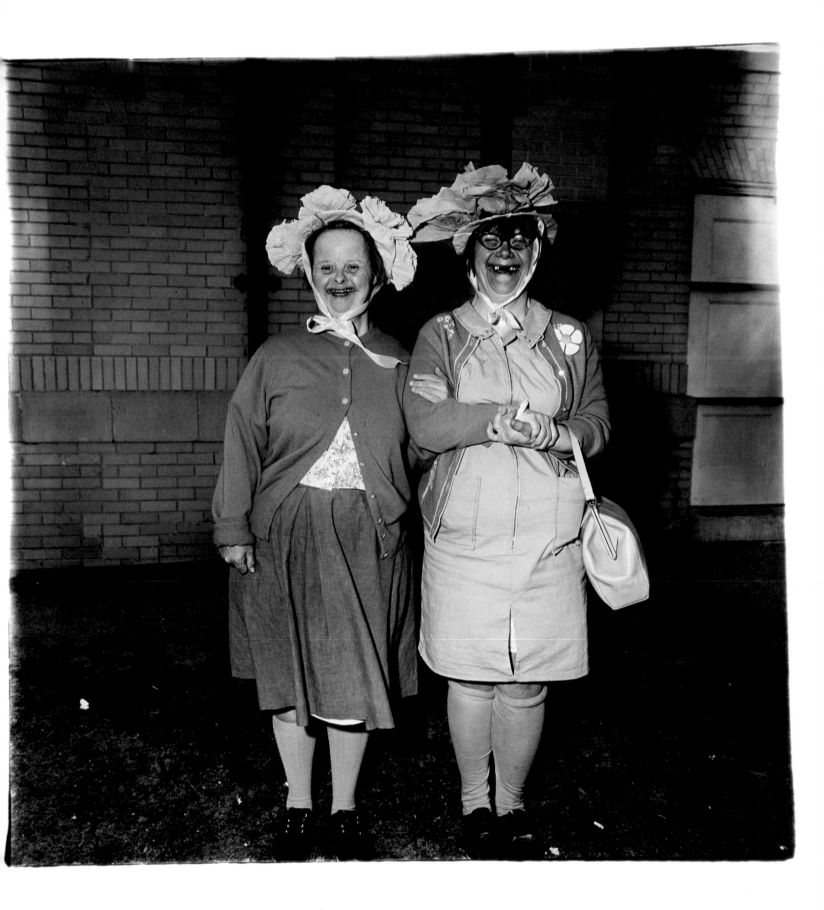

Untitled (2) 1970-71

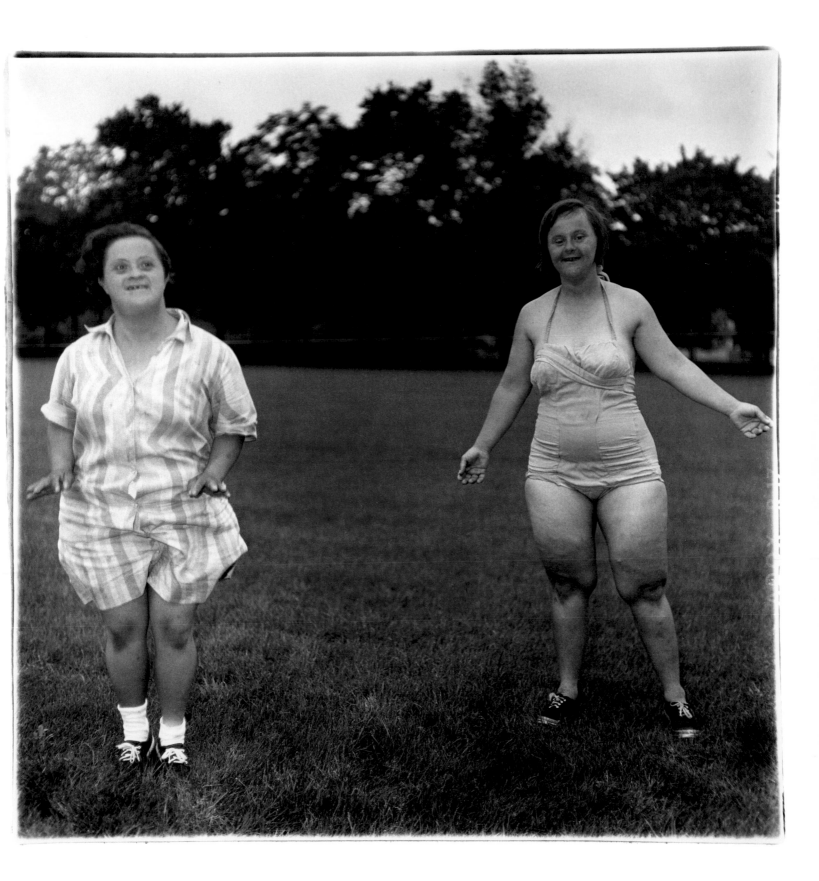

Untitled (3) 1970-71

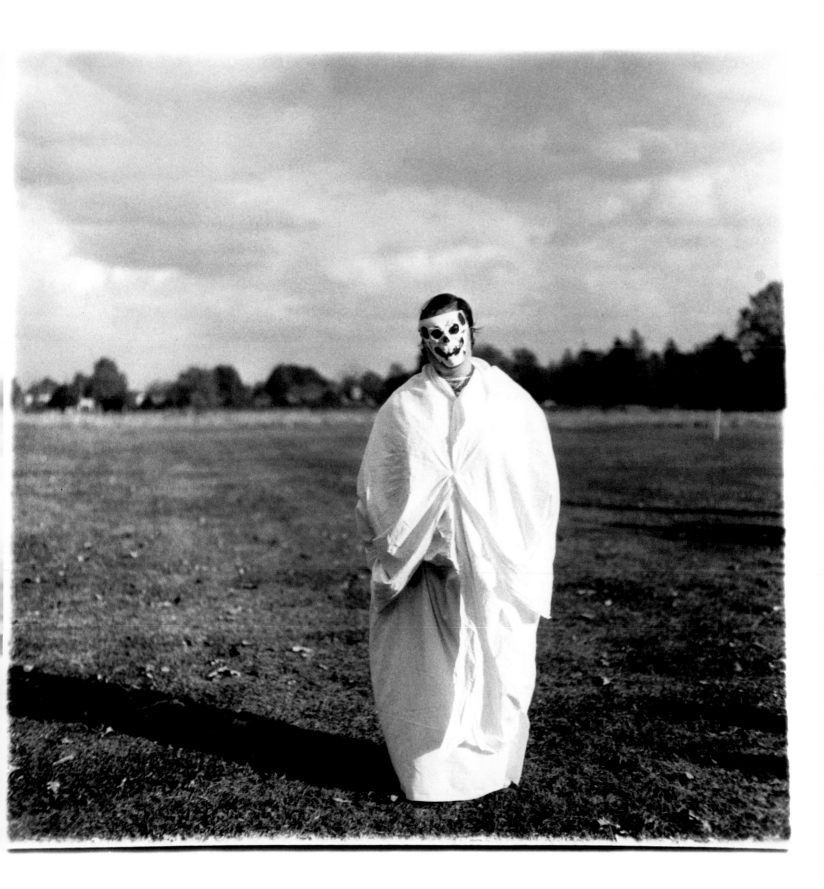

Untitled (4) 1970-71

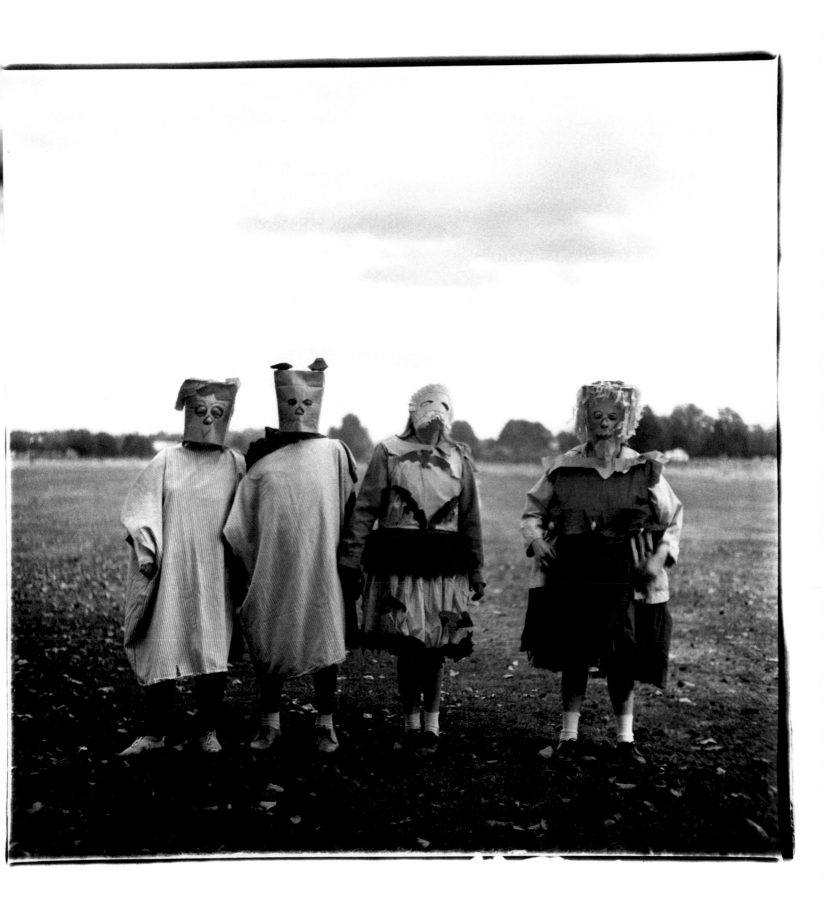

Untitled (5) 1970-71

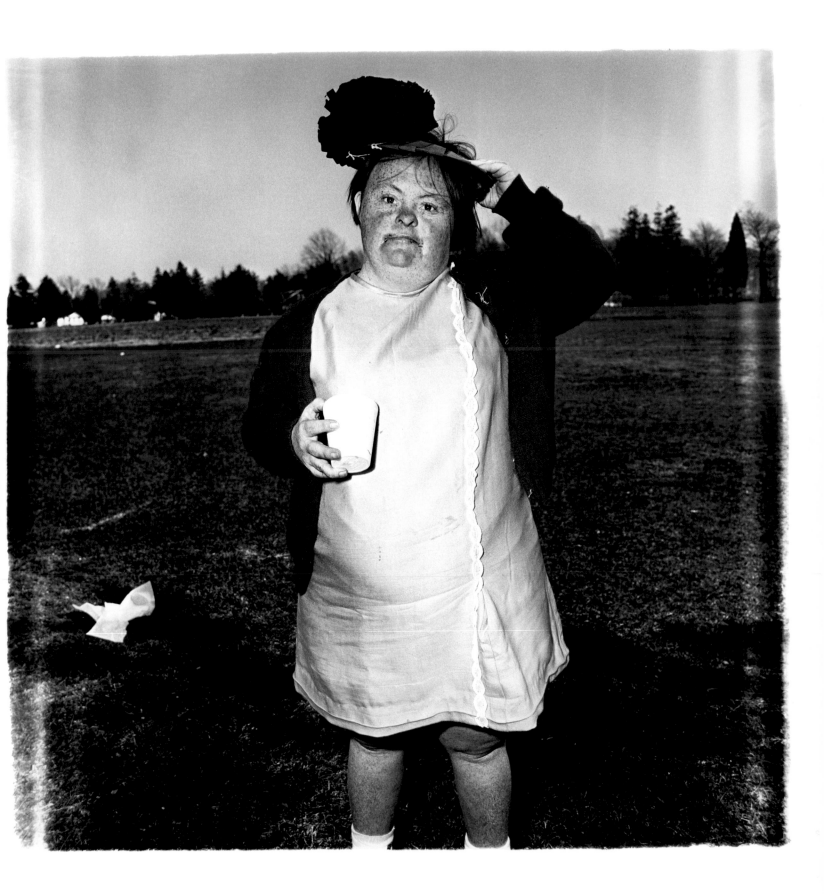

Untitled (6) 1970-71

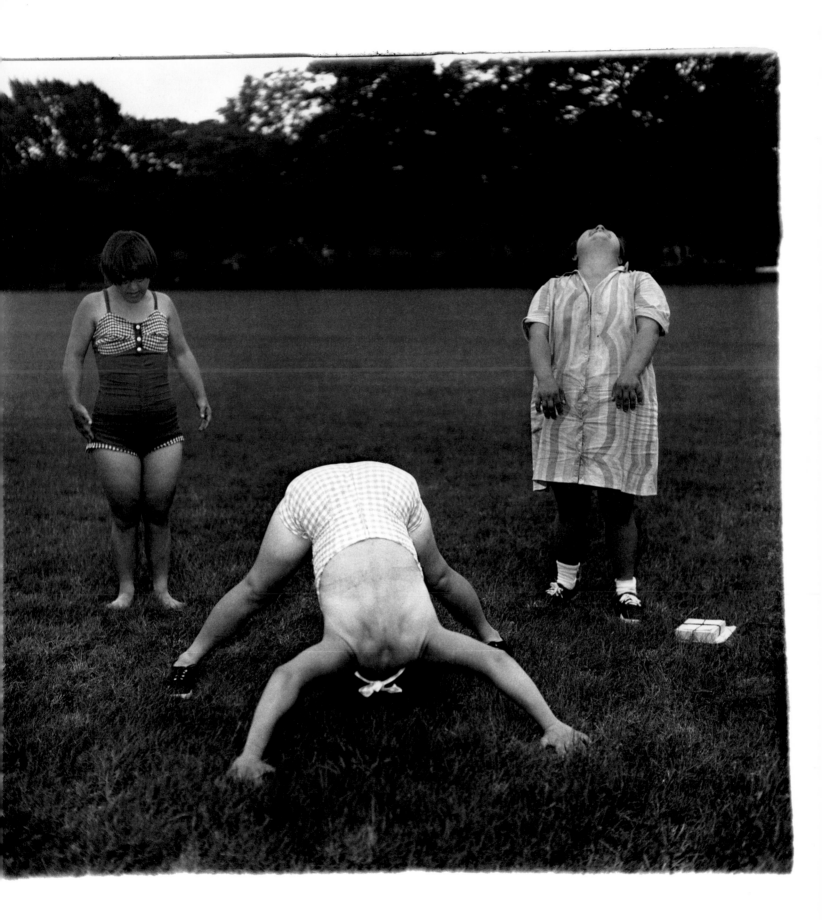

Untitled (7) 1970-71

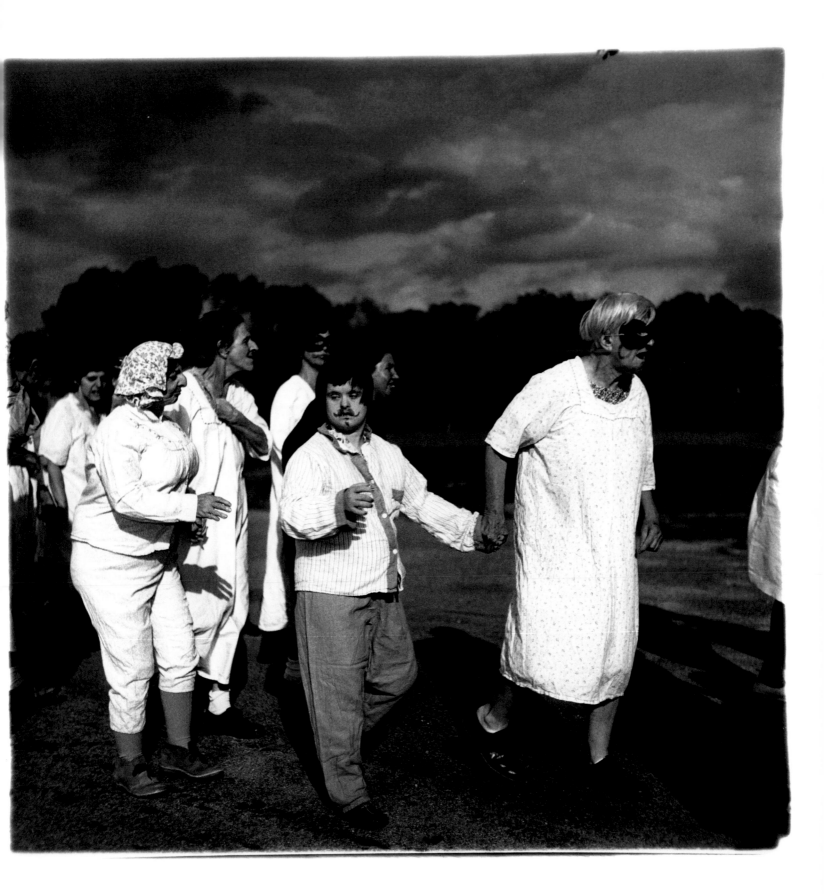

This book was edited and designed
by Doon Arbus, Diane Arbus's daughter, and
Marvin Israel, Diane Arbus's friend.
New York City, 1972.